IMAGES of Sports
BOSTON'S BOXING HERITAGE
PRIZEFIGHTING FROM 1882 TO 1955

IMAGES
of Sports

BOSTON'S BOXING HERITAGE
PRIZEFIGHTING FROM 1882 TO 1955

Kevin Smith

Copyright © 2002 by Kevin Smith
ISBN 978-0-7385-1136-8

Published by Arcadia Publishing
Charleston, South Carolina

Printed in the United States of America

Library of Congress Catalog Card Number: 2002110596

For all general information contact Arcadia Publishing at:
Telephone 843-853-2070
Fax 843-853-0044
E-mail sales@arcadiapublishing.com
For customer service and orders:
Toll-Free 1-888-313-2665

Visit us on the Internet at www.arcadiapublishing.com

For Dennise, Aevary, Sean, Nancy, and Tom

CONTENTS

Acknowledgments		6
Introduction		7
1.	The Boston Strong Boy	9
2.	The Boston Tar Baby	57
3.	The Boston Gob	81
4.	The Rock and the Brown Bomber	119

Acknowledgments

I wish to thank the following people for their assistance in putting this book together: Ben Hawes who so unselfishly sent me hundreds of photographs of pre-1900 boxers and some very rare Sam Langford negatives; Tracy Callis who was integral to the gathering of accurate and detailed information on many of the fighters discussed within; Bob Carson for sharing his wonderful collection on African American boxers with me; Dave Bergin of Dave's Classic Collectibles for his willingness to send anything that I requested and, many times, just getting me stuff he thought I could use; and Mike Delisa, a man of many projects, who really started me on this one.

INTRODUCTION

Fighting is as old as mankind. From the first time that two men saw it fitting to square off with one another in physical combat, man found a certain sport in fighting. Throughout Boston's 300-plus year history, the sport has been ever present in the city. Although it has gone through many stages, pugilism, boxing, or as it is sometimes called, "the sweet science," has filled the city's history with some of its richest and most interesting characters. Perhaps no one man demonstrates this more than Boston's first son: John L. Sullivan.

Prizefighting was no more than a whisper in Boston during the late 1870s. There were always the traveling pugilists who would exhibit their art on the stages of the city and a number of very good local boys, but at that time, prizefighting was not nearly as popular as baseball, bicycling, or even competitive walking. Still considered by most an illegitimate and criminal pastime, prizefighting was practiced and supported mainly by the underbelly of society. There were those who tried to legitimize the sport by calling it the "science of self defense," but the mainstream still viewed it as a disgrace. Sullivan would change all that.

John Lawrence Sullivan was born in Roxbury in 1858. He was the man who took boxing on his broad shoulders and brought it to the forefront of the collective American consciousness. He did more for prizefighting during his 10-year reign than any before or after him. His contribution was more than simply making the sport popular; he revolutionized how the sport was practiced and how lawmakers and world leaders alike would view it.

Sullivan appealed to all classes of people. He himself was a working-class man, raised in the home of hardworking immigrant parents who, like many in America at that time, had to scratch, bite, and kick just to remain alive. Sullivan's appeal to the working class was obvious, and for all his fame and fortune, he never lost his ability to relate to the workingman. His fortune was theirs, for he symbolized every man's ability to rise up from any status to the ultimate in success and fortune. For them, he was the realization of the American Dream. But the middle and upper classes liked Sullivan as well, and it was their embracing of the "Boston Strong Boy" that would bring prizefighting to the height of popularity in the United States. Their reasons were far different than those of the working class. They saw in Sullivan the expression of violence and primal urge, of recklessness and emotion—all things that they had been told to suppress as proper Victorian-era citizens. The press also liked the Boston Strong Boy because his behavior was the kind that made great copy, and great copy sold papers. He was the ultimate celebrity and America's first sporting hero. Some called him America's first citizen, and during his heyday, it was no exaggeration when he was referred to as the most famous man in the world.

Sullivan's reign lasted from 1882 until 1892. During that time, Boston became a hotbed for boxing and featured such distinguished boxing clubs as the Cribb Club and the Casino Athletic Club in the South End. Prizefighters came from around the country to Bean Town because it was now *the* place for good matches and good purses. Out of this new popularity sprang two more world champions prior to the end of the 19th century: Paddy Duffy, the first welterweight champion of the modern era, and the famous double champion George Dixon who won the World Bantamweight Championship in 1890 and the World Featherweight Championship in 1891.

As the 19th century spilled into the 20th, Boston saw no decline in the popularity of prizefighting. In fact, as anti-prizefighting legislation and enforcement grew more lax, more and more clubs opened and more and more fighters came to fill them. Boston also continued its championship run. Between 1901 and 1908, the World Welterweight Championship was always in the possession of a Boston fighter (with the exception of a six month period in 1904). The foursome of "Barbados" Joe Wolcott, "Honey" Mellody, Mike "Twin" Sullivan, and Jimmy Gardner accomplished this remarkable feat. In 1902, Boston also gave birth to the fighting career of Samuel Langford, who fought for more than two-and-a-half decades and was quite possibly the best fighter to ever live. From 1910 through 1919, boxing suffered a slight decline in popularity across the United States but maintained its popularity in Boston.

The Roaring Twenties brought with it a fanaticism about the fight game that had not been seen since the days of John L. Sullivan. Led by a charismatic heavyweight champion by the name of Jack Dempsey, boxing between the years 1919 and 1926 grew from a simple sport into a multi-million-dollar business. The golden age of boxing in Boston was a busy time. For most of the decade, there were three to five major shows each week in Boston alone and many more in surrounding communities. Bean Town's strong love for the sport spurned Tex Rickard, a famous promoter and matchmaker at Madison Square Garden in New York, to spearhead the building of the Boston Garden in 1928.

The 1930s saw a decline in the popularity of boxing nationwide due to the Depression and the fact that there was no truly great heavyweight champion for several years. Boston remained fairly busy, but even after Jack Sharkey, the "Boston Gob," had won the heavyweight crown in 1932, interest in boxing was waning. However, when Joe Louis won the heavyweight title in 1936, boxing was again at the foot of a master. Deadly, cool, and dominating, Louis created another boxing boom through his powerful punching displays and his utter dominance of the division. Louis's reign lasted through the war years and a bit beyond his championship, passing to Ezzard Charles and then "Jersey" Joe Wolcott, both very good fighters but not as impressive as Sullivan, Dempsey, or Louis. Enter Rocky Marciano. The "Brockton Blockbuster" would bring a new sense of fistic pride to the area, and when he won the World Heavyweight Championship in 1952, the Boston fans came out again in droves.

One

THE BOSTON STRONG BOY

"I Am John L. Sullivan!"

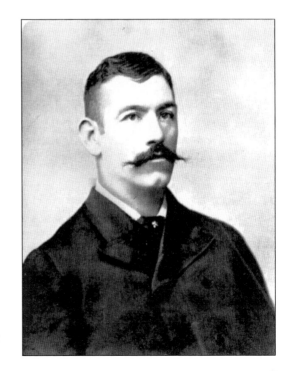

JOHN L. SULLIVAN, C. 1888. The most important sport personality of his time, John L. Sullivan stood as a symbol of American individualism, achievement, and determination. Born to poor Irish parents in Roxbury in 1858, Sullivan rose from the streets of Boston to capture what was once called the most important prize in sports: the World Heavyweight Championship. He did so with a fierce arrogance, natural brute strength, and a bit of promotional genius. He revolutionized the sport of prizefighting and brought it from an illicit back-room undertaking to the most popular of sports. (Author's collection.)

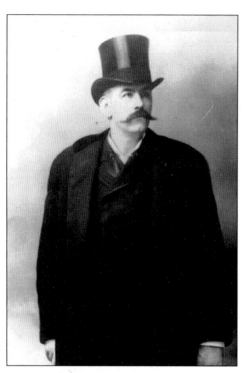

JOHN L. SULLIVAN IN EVENING DRESS, c. 1883. John L. Sullivan got his start in 1877 when he visited the Dudley Street Opera House to watch a fighter by the name of Tom Scannel take the stage and spar a few rounds with a predetermined audience member. Sullivan was keen to the act and shouted a challenge to Scannel. Scannel was a professional who saw little danger in crowning the loud mouthed Sullivan and invited him to the stage. Sullivan rolled up his sleeves and offered his hand in gesture of a traditional handshake, but Scannel punched him in the nose instead. As quick as Scannel's fist had landed on Sullivan's proboscis, the veteran fighter found himself knocked off the stage into the orchestra pit. On that day, a legend was born. (Ben Hawes's collection.)

BILLY MADDEN, c. 1882. Billy Madden took over the reigns of Sullivan's early career serving as both a manager and sparring partner. Madden had a fairly distinguished career as a fighter himself and found that his experiences as a self-managed prizefighter would serve him well as he attempted to guide the young boxer into the limelight. It was Madden who would introduce Sullivan to men like William Muldoon and places like the famous Harry Hill's. (Ben Hawes's collection.)

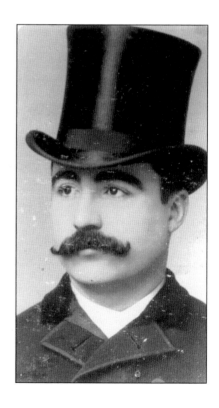

JOHN L. SULLIVAN IN A FIGHTING POSE, c. 1889. There was nothing fancy about John L. Sullivan's fighting style. The famous professor Mike Donovan, who sparred with Sullivan in Boston during the winter of 1880, may have best described his manner of attack when he wrote in his 1909 book *Memories of Other Fighting Men*: "His [Sullivan's] attack—he had no defense—was utterly simple. He used his right as a blacksmith would use a sledge hammer to pound a piece of iron into shape, straight down, slamming away the other man's guard, for he was unbelievably strong, and then he would knock his man out with either a straight right to the jaw or a right hook to the side of the neck, his favorite punch."(Ben Hawes's collection.)

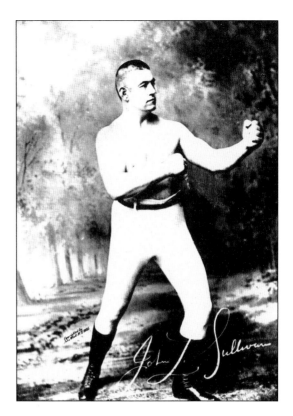

BILLY MADDEN IN A FIGHTING POSE, c. 1880. Like Sullivan, Billy Madden was born in Boston. His career led him on several tours across the United States, and by the time he met Sullivan, he was a worldly man who new the role that publicity and ballyhoo would play in the development of a prizefighting career. His first and probably shrewdest move as Sullivan's manager was to take the fighter to New York in 1881, where the daring Madden offered $250 to any man who could last four rounds with the "Boston Strong Boy." Steve Taylor, a pugilist of some note, took the challenge and was defeated by Sullivan in two rounds. (Ben Hawes's collection.)

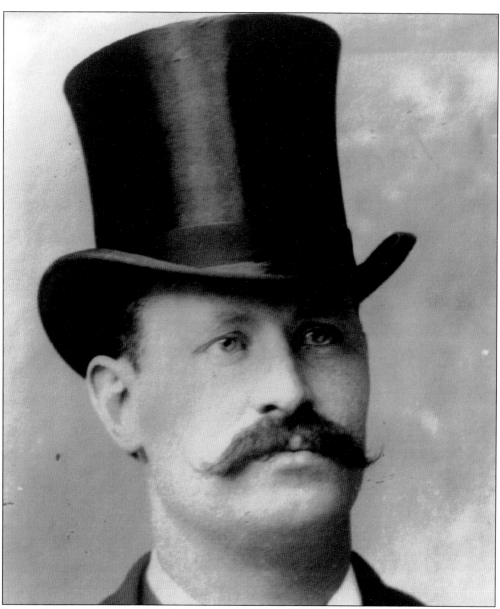

PADDY RYAN, C. 1882. Paddy Ryan was the recognized heavyweight champion of America when he met John L. Sullivan for the title in Mississippi City on February 7, 1882. Ryan was actually a better wrestler than boxer but, nevertheless, had been recognized as the champion since 1880 when he had defeated Joe Goss in a marathon bout which lasted 87 rounds and took 1 hour and 24 minutes to complete. Even in that match, Ryan had shown little ability as a boxer. His victory was more a matter of his size and stamina outlasting Goss's advanced age and lighter weight. The Ryan-Sullivan match was staged on the lawn of the Barnes Hotel. The men and, by some reports, women who made up the gathering were a motley mix of thieves, gamblers, and outlaws. There were even ringsiders who claimed that they had rubbed elbows with the likes of Jesse and Frank James. The fight was far less scintillating. Sullivan had little trouble with Ryan and knocked him out in 9 rounds to win the title. (Ben Hawes's collection.)

A SKETCH OF BILLY MADDEN, 1882. After several disagreements, many over a woman, John L. Sullivan and Billy Madden went their separate ways. Madden, realizing that by early 1882 Sullivan was more than just another champion, ventured to England in the hopes of finding a challenger for the crown. He held a series of tournaments in Chelsea Baths, England, advertising them as elimination contests. The winner would then be brought to America to fight Sullivan. Charley Mitchell, a Birmingham middleweight of considerable skill, won the tournament easily and left with Madden for America. (Author's collection.)

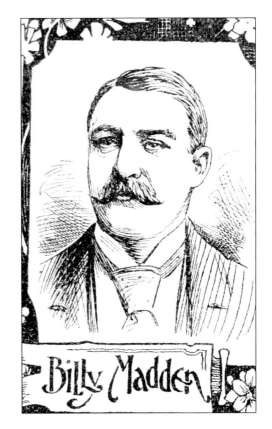

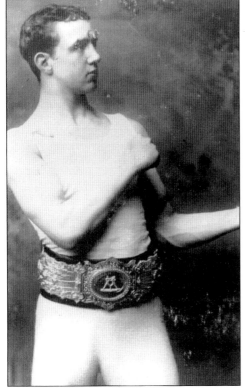

CHARLEY MITCHELL IN A FIGHTING POSE, 1883. Mitchell weighed 150 pounds when he faced-off with the 190-pound John L. Sullivan at New York's Madison Square Garden on May 14, 1883. Poor Mitchell seemed a bit overmatched when Sullivan sent him to the floor twice in the first round. But Mitchell became a fiery competitor when Sullivan moved in to finish him off, and he did the unthinkable; he knocked the champion on his ear. Sullivan was up without a count but was so embarrassed and enraged—it was the first knockdown he had ever suffered in the ring—that he nearly killed the Englishman. In the third round, after Sullivan trapped Mitchell against the ropes and pummeled him unmercifully, the police entered the ring and stopped the bout. (Ben Hawes's collection.)

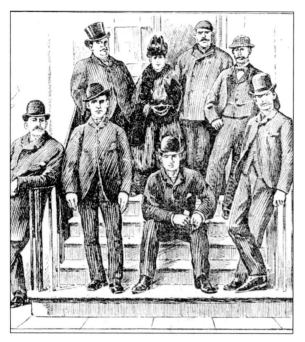

SULLIVAN'S TRAINING QUARTERS IN WINDSOR, ENGLAND, 1883. John L. Sullivan ventured to England in 1888 in order train for his rematch with Charley Mitchell, which was to take place in Chantily, France, on the private estate of Baron Rothchild. Sullivan took few chances with his training, and in addition to his own American trainer, Jack MacDonald, he enlisted the services of the renowned English trainer Chippy Norton. The group set up camp at the plush Royal Adelaide Hotel in Windsor. Shown here, from left to right, are as follows: (front row) Harry Phillips, Sam Blakelock, Jack Ashton, and Ned Holske; (back row) Chippy Norton, ? Bull, John L. Sullivan, and Jack MacDonald. (Author's collection.)

QUEEN VICTORIA WATCHES AS JOHN L. SULLIVAN TRAINS, 1883. Sullivan's celebrity was such that he not only sparred in front of the Prince of Wales but also enjoyed the presence of Queen Victoria at his training quarters. His impressions of the prince were favorable, and John noted, "He was a nice sociable fellow with fine manners." (Dave Bergin's collection.)

A BUST OF PETE MCCOY 1883. Pete McCoy was born in South Boston. A clever lightweight with good footwork and dazzling hand speed, McCoy claimed the lightweight and middleweight championships of Boston. His most famous opponent was world middleweight champion Jack Dempsey, who beat McCoy in a six-round bout in 1886. (Ben Hawes's collection.)

JACK ASHTON IN A FIGHTING POSE, 1883. Jack Ashton was a decent heavyweight from Providence, Rhode Island. He fought some of the better men of his day, including George Godfrey and Joe Lannon, but was best known as John L. Sullivan's favorite sparring partner. Ashton, like Sullivan, was a big spender and a big drinker. His relationship with the champion was an odd one. He revered Sullivan although the latter had never treated him as anything better than a plaything. Often the butt of Sullivan's cruel jokes, Ashton remained loyal to the champion until the end. After Sullivan's fall from grace in 1892, Ashton took heavily to the bottle. He died less than a year later at the age of 30 from the affects of what was termed erysipelas. (Ben Hawes's collection.)

PETE McCOY IN A FIGHTING POSE, 1880. Pete McCoy was a dear friend of John L. Sullivan's. The two sparred frequently during stage exhibitions and worked together when Sullivan trained for official bouts. McCoy traveled with the Sullivan tour of 1883, where he and Mike Gillespie would warm up the crowds with four lively rounds of sparring before Sullivan would take the stage to "meet all comers." After the tour had reached its halfway point, Sullivan's drinking binges became more frequent, as did his violent outbreaks. After Sullivan and McCoy engaged in a brawl, which terminated when McCoy broke a chair over Sullivan's head, Pete left the tour and returned to Boston. He and Sullivan later reconciled, but McCoy died tragically in 1893 when he jumped from his brother-in-law's tugboat into the waters of Long Island Sound and drowned. (Ben Hawes's collection.)

DOMMINICK MCCAFFREY, 1885.
Domminick McCaffrey was a fine fighter who met some of the best men of his time, including James Corbett, Jack Dempsey, and John L. Sullivan. His contest with Sullivan, in which he was defeated in seven rounds on a decision, was the first to be fought under the Marquis of Queensbury rules, which are in essence the same rules that govern boxing today. (Ben Hawes's collection.)

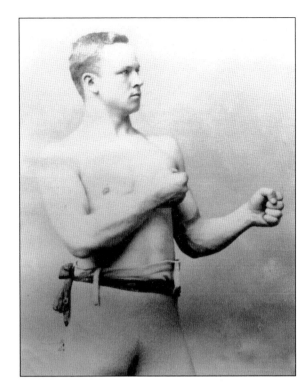

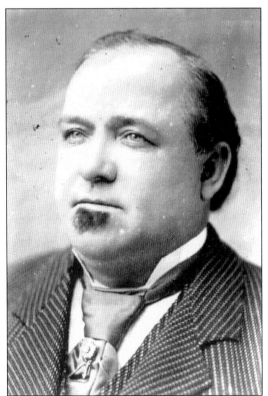

THE WEALTHY JAMES KEENAN, 1882.
A famous Boston patron or "sport," James Keenan was first a horse man and second a fight man. His wealth—he was a very wealthy man—came from an odd mixture of moxy, luck, and a stable of horses that he kept on a small farm in Billerica. His foray into the fight game came to a peak when he backed Sullivan with the $2,500 he needed to fight Paddy Ryan. (Ben Hawes's collection.)

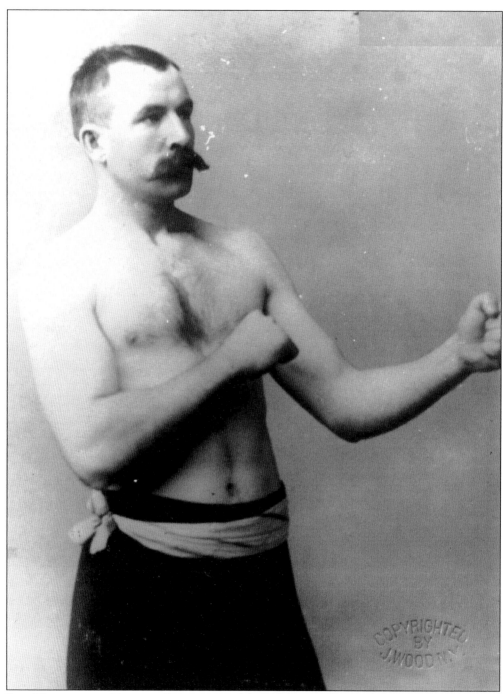

JAKE KILRAIN IN A FIGHTING POSE, 1888. Jake Kilrain was born in New York and came to Boston as a young man. He worked in a rolling mill in Somerville before turning to prizefighting as an occupation. Most of his early bouts were in Boston, and Kilrain eventually acquired enough skill and reputation that he began giving boxing lessons at the Cribb Club. A devout family man, he was one of the few pugilist who saved the money that he earned throughout his career. (Ben Hawes's collection.)

RICHARD K FOX, 1889. Richard Fox was the publisher of the scandal and sport sheet known as the *Police Gazette*. Fox had developed a deep hatred for John L. Sullivan after being snubbed by him at Harry Hill's in 1881. Fox spent years trying to find the man to defeat the brash Sullivan, and it was the publishing magnate who brought Jake Kilrain to the forefront as Sullivan's greatest challenge. (Ben Hawes's collection.)

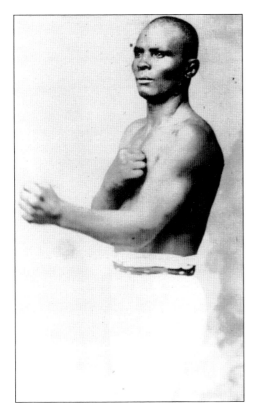

DANGEROUS JACK. Jack Watson was a Boston native, born in the West End to West Indian parents. His main claim to fistic fame was his three-round bout with a young Kilrain in 1880. Watson was known for his ability to dance and sing and could often be found in the markets performing for money. (Author's collection.)

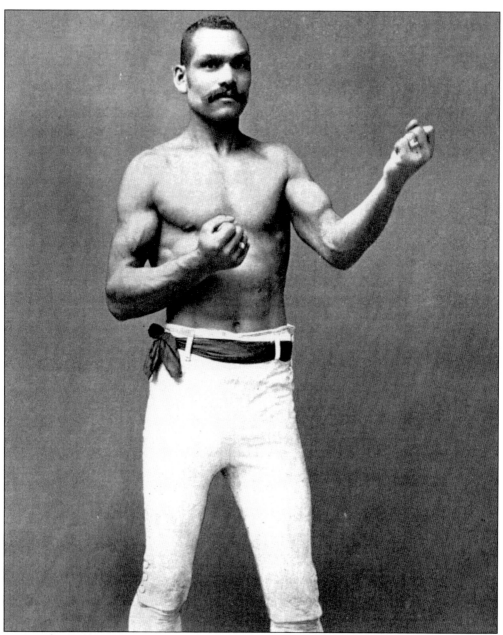

GEORGE "OLD CHOCOLATE" GODFREY, 1885. George "Old Chocolate" Godfrey was born on Prince Edward Island in 1853 but moved to Boston as a young man. He settled in Chelsea and was working as a silk porter when he came under the tutelage of Professor John Bailey who ran a gymnasium on Cross Street. Bailey arranged Godfrey's early bouts, and he quickly earned himself a reputation as a prizefighter. After sojourning to Harry Hill's in New York in 1881, where he fought a draw with the clever Charles Hadley, Godfrey was matched to meet John L. Sullivan at Bailey's gymnasium on September 7, 1881. By some accounts, both men where stripped and ready to fight when the police broke in and stopped the proceedings. Other accounts state that upon entering Bailey's quarters, Sullivan, for unknown reasons, refused to fight. (Author's collection.)

PROFESSOR CHARLES HADLEY. Charles Hadley hailed from Bridgeport, Connecticut, where he was a student of the famous fighter Ed McClinchey. Hadley fought almost exclusively against other black men and was very successful in doing so. No more than a heavy middleweight, Hadley ventured to Harry Hill's in 1880 to try his wares in a tournament that was advertised as a contest for the "Colored Championship." Hadley won the tournament and stayed on at Harry Hill's for close to two years taking on all comers. He lost one bout in that time. Hadley began his prizefighting career in 1869 and was 34 when he debuted at Harry Hill's in 1880. As his age and career extended, he began loosing far more bouts than he won. His most famous battle was his match with George Godfrey in Boston in 1883. (Author's collection.)

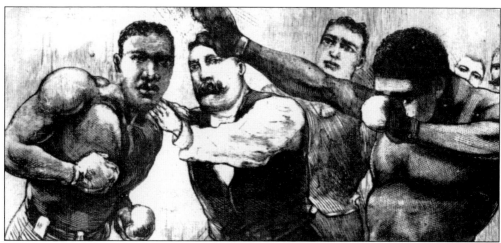

GEORGE GODFREY VERSUS PETER JACKSON SKETCH, 1888. George Godfrey met perhaps his greatest antagonist in the person of Peter Jackson, the "Black Prince." Jackson, a transplanted West Indian who claimed Australia as his home, landed in San Francisco in the spring of 1888 with a reputation as a world beater. Unable to find any white heavyweights of merit to share the ring with him, the Black Prince took on Godfrey, the best available black fighter in America. The two fought a slashing battle, but the 200-pound Jackson was too heavy, quick, and skillful, and he stopped Godfrey in 19 rounds. (Author's collection.)

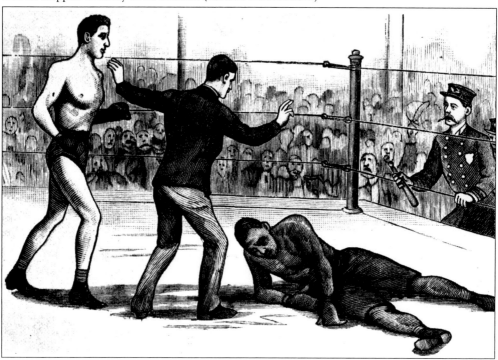

GEORGE GODFREY VERSUS JOE CHOYINSKI, 1892. A battered and beaten George Godfrey lies before the great Joe Choyinski as a policeman climbs into the ring to stop the bout. Choyinski and Godfrey were evenly matched in weight, but Godfrey's advanced age (he was 39 years old in 1892) told in the latter rounds. After a spirited battle, Choyinski finished Old Chocolate with a smashing right in the 15th round. (Author's collection.)

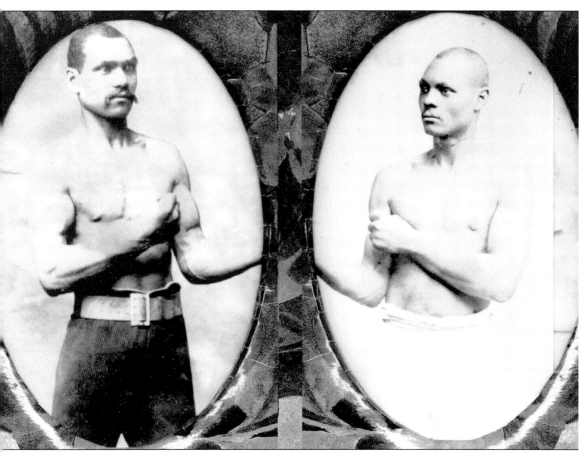

A George Godfrey versus Professor Charles Hadley Advertisement Plate, 1883. George Godfrey made his reputation by hanging tough with the more experienced Charles Hadley when the two met in New York in 1879. But when they met at the Cribb Club in Boston on a winter evening in February of 1883, Godfrey asserted his dominance. Prior to the bout, there was a bit of gamesmanship carried out by Hadley when he insisted on John L. Sullivan as referee. Hadley knew that Sullivan had refused several offers to meet Godfrey in the ring and hoped that this selection might unnerve or even anger Godfrey. In a move of utter confidence, Godfrey turned the tables on Hadley and readily agreed on Sullivan as the choice for referee. Old Chocolate then proceeded to dominate Hadley and knock him out in six rounds, winning recognition as colored champion in the process. (Author's collection.)

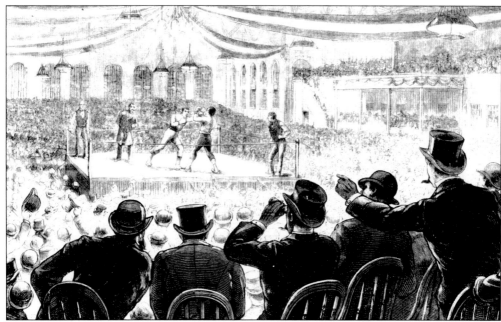

JAKE KILRAIN VERSUS CHARLES MITCHELL IN THE MECHANICS HALL, 1884. Rising star Jake Kilrain meets the former challenger to John L. Sullivan, Charley Mitchell, at the plush Mechanics Hall in 1884. The two fought a four-round draw, but Kilrain had to wait nearly five more years for his chance with Sullivan. The Mechanics Hall was the boxing showcase for many decades and served as one of the main fight venues of Boston through the 1920s. (Author's collection.)

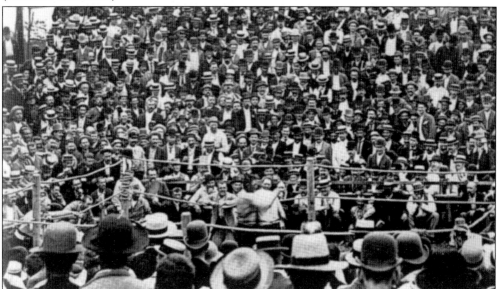

JAKE KILRAIN VERSUS JOHN L. SULLIVAN, 1889. Sullivan, on the right, attacks Kilrain in the early rounds of their historic 75-round battle at Richburg, Mississippi, on July 8, 1889, which was won by Sullivan. Sullivan outlasted Kilrain in what would prove to be the last ever bareknuckle bout fought under the London Prize Ring rules for the heavyweight title. (Mike DeLisa's collection.)

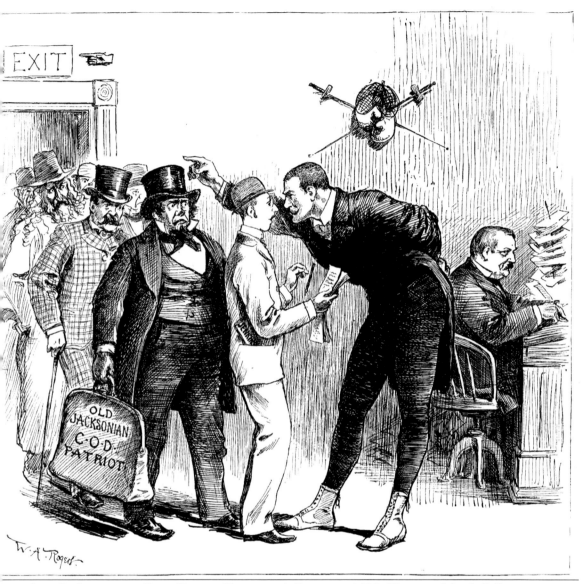

JOHN L. SULLIVAN AS PRES. GROVER CLEVELAND'S BOUNCER, 1887. The great John L. Sullivan protects the hard-working, newly elected Pres. Grover Cleveland from a host of reporters, office seekers, and political aspirants. The cartoon clearly reflects Sullivan's notoriety as well as his affect on the press's coverage and attitude towards boxing. (*Harper's Weekly*.)

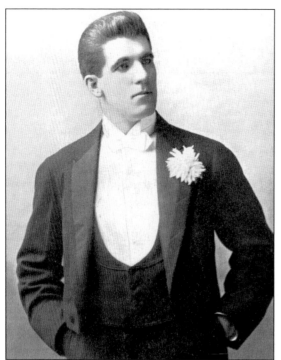

JAMES "GENTLEMAN JIM" CORBETT, 1891. A handsome bank clerk from San Francisco, by 1891 James "Gentleman Jim" Corbett had quickly fashioned himself into one of Sullivan's leading challengers. Upon hearing of Corbett's cries for a championship match, Sullivan was reported to have said, "Have him go get himself a reputation." Corbett did him one better by meeting Peter Jackson, the man Sullivan had steadfastly refused to fight because he was black. The lighter and less experienced Corbett held the great Jackson to a draw over 61 rounds and earned himself a shot at Sullivan. (Ben Hawes's collection.)

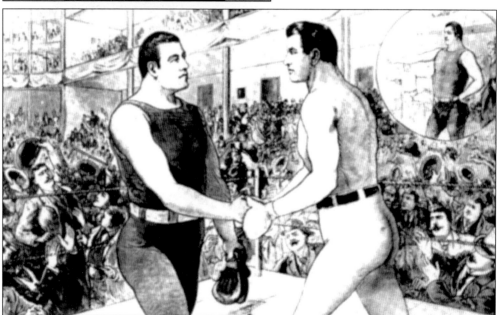

CORBETT VERSUS SULLIVAN, 1892. Sullivan, on the right, shakes hands with Corbett prior to their bout at the Olympic Club in New Orleans. A terribly bloated and tired Sullivan landed a few blows but none of them had the same force or speed that made him the most feared man on the planet for close to 10 years. Corbett, introducing a new style of "scientific" boxing, danced around Sullivan and easily countered with short sharp blows. Corbett eventually knocked out Sullivan in the 21st round and, thus, ended one of the greatest reigns in boxing history. (Ben Hawes's collection.)

MIKE SULLIVAN, BROTHER OF JOHN L., 1883. John L. Sullivan often bragged that his brother Mike would turn out to be a greater man than he himself, but in essence, that was merely brotherly love. The younger Sullivan was a small and sickly man, and in 1891, he suffered several heart attacks. He died in 1895 at the age of 29 from Bright's disease. John felt the loss of his brother intensely. (Ben Hawes's collection.)

"ROB ROY" BENTON, c. 1890. "Rob Roy" Benton was a man of many faces who served as a boxing manager for such fistic luminaries as Jack McAuliffe, Charles "Kid" McCoy, Sam McVey, and "Mysterious" Billy Smith. Rob Roy, whose real was Benjamin, was also a boxing writer for the *Boston Herald*, the *Boston Globe*, and the *Boston Post*. He served as editor of the *Police News* and *Rob Roy's Weekly*, both sporting sheets that covered boxing substantially. Benton was active as a promoter as well, serving for many years as the matchmaker at the esteemed Cribb Club in Boston. (Author's collection.)

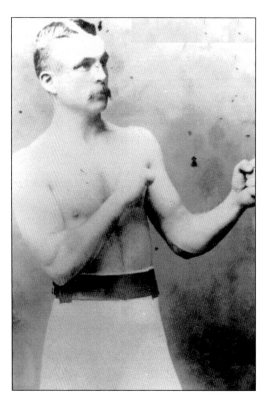

BILLY FRAZIER IN A FIGHTING POSE, c. 1880. Billy Frazier, a native of Eastport, Maine, had a career that spanned 23 years, beginning in 1870 and ending in 1893. A lightweight of considerable speed, Frazier had several cracks at Jack McAuliffe, world lightweight champion, none of which he won. Their most famous battle was a 21-round war in Boston, which ended with Frazier being counted-out on the canvas. (Ben Hawes's collection.)

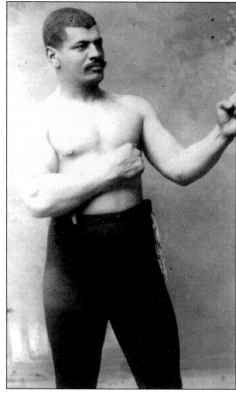

BILLY WILSON IN A FIGHTING POSE, c. 1884. Billy Wilson was a powerful heavyweight. He lived in Boston for a number of years and fought several exhibition bouts with Charles Hadley in 1883. He often trained at Narragansett Beach and was very fond of the South End watering holes. Unable to secure any real bouts in Bean Town and with his debt growing, Wilson left Boston in the summer of 1884. (Ben Hawes's collection.)

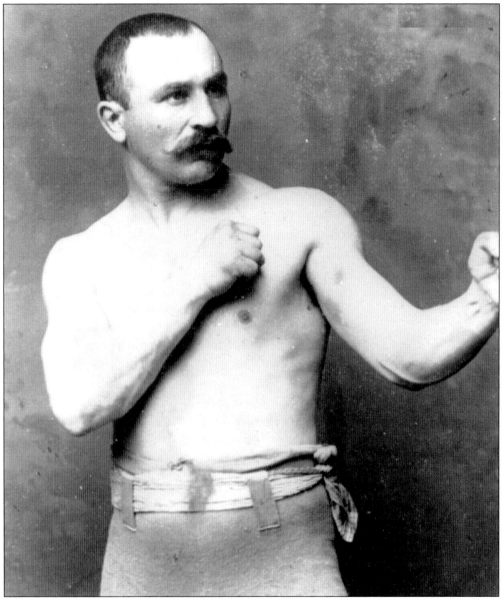

GEORGE THE "MARINE" LEBLANCHE, C. 1887. George Leblanche, whose proper name was George Blais, was born in Canada and came to Boston as a teenager. There he joined the marines where he began taking part in impromptu bouts put on by the soldiers. Leblanche, the "Marine," as he was called, was skilled enough that a number of local Boston sports arranged for his discharge from the service so that he might begin fighting as a professional. He made his professional debut against George Smith in a 6-round draw at the Cribb Club in 1883. His 1884 draw with Pete McCoy earned him great accolades and thrust him into a match with middleweight champion Jack Dempsey, the "Nonpareil." Leblanche fought well but was knocked out in 13 rounds. After regrouping with a number of well earned victories, he was again matched with Dempsey. Turning the tables this time, Leblanche knocked out Dempsey in the 32nd round. However, his use of an illegal pivot blow to turn the trick cost him the win and the middleweight title. (Ben Hawes's collection.)

PADDY DUFFY IN A FIGHTING POSE, C. 1888. Perhaps Boston's least known world champion is Paddy Duffy. Born and raised in South Boston, Duffy began prizefighting in 1884. Between his debut and his championship match with Billy McMillian in October 1888, Duffy lost only one contest. His bout with McMillian is recognized today as the first championship battle fought under the Marquis of Queensbury rules for the World Welterweight Championship. Duffy knocked out McMillian in 17 rounds at Fort Foot, Virginia. He then played the exhibition circuit until he defended his title by winning on a foul in 45 rounds against Tom Meadows in March 1889. Duffy never defended his title again. He died on July 19, 1890, of unknown causes. (Ben Hawes's collection.)

DENNY KELLIHER IN A FIGHTING POSE, c. 1886. Denny Kelliher was a clever middling fighter. A smallish heavyweight, his greatest contests were of the gloved variety and could be considered exhibitions more than actual ring combat. He shared the ring with such men as Joe Choyinski, Domminick McCaffrey, and immortals Jack Dempsey and Peter Jackson. (Ben Hawes's collection.)

BILLY HENNESSEY IN A FIGHTING POSE, c. 1893. Billy Hennessey was a native of Iowa, but the most important ring battles of his career took place in Boston. Hennessey was based out of Bean Town from 1893 through late 1895. He fought two contests with Dick O'Brien in 1894: one an exhibition and the other a fierce brawl in which Hennessey was knocked out in the 11th round. He was knocked out again in 1895 by Dan Creedon of Australia but scored the greatest ring victory of his career in 1896 when he knocked out George Leblanche, the Marine, in one round at the Kirkland Club in Lynn. (Ben Hawes's collection.)

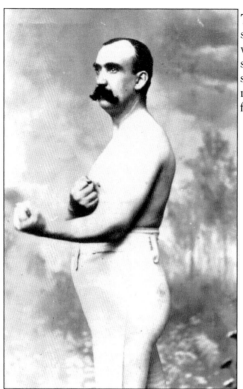

TOM EARLY, 1880. A bareknuckle fighter of some success, Tom Early, pictured here in 1880, was considered one of the "old guard" in Boston sporting circles. He preferred gloved matches for scientific points and often gave lessons to the more affluent members of Boston's upper crust for $5 a session. (Ben Hawes's collection.)

EARLY OPENS A GYMNASIUM, 1888. Early took the money that he had earned through exhibitions and lessons and opened a gymnasium, which he called Tom Early's Rooms. He was a bit ahead of his time, and by the mid-1880s, he was promoting matches between black and white fighters—a practice that was still frowned upon in many sectors. One of the many fighters whom he helped develop was Ed Binney, the "Boston Black."

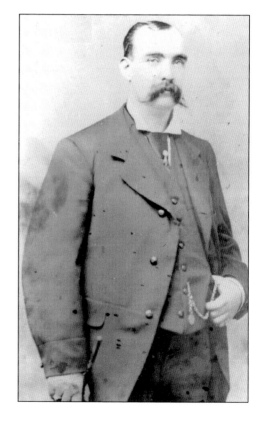

THE BLACK PRINCE. Perhaps the best heavyweight of his time, the famed Black Prince of Australia, Peter Jackson, never received his title shot. The most consistent and worthy challenger to John L. Sullivan could never coax the Boston Strong Boy into the ring with him. Even a $50,000 offer from the California Athletic Club was not enough to change Sullivan's stance against meeting a colored opponent.

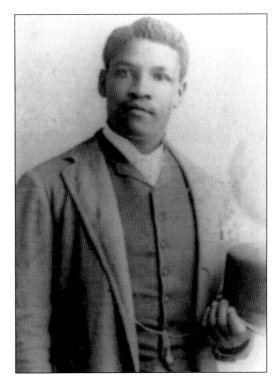

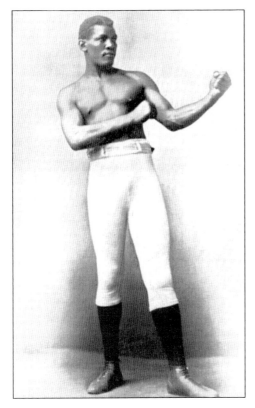

PETER JACKSON IN A FIGHTING POSE, 1890. Jackson's famous draw with future world champion James Corbett was a microcosm of his plight. Because of his showing against Jackson, Corbett was granted his shot at Sullivan's title. For his part, Jackson received only more frustration. He continued to fight here and there, giving exhibitions, and he opened a gym where he taught the finer points of boxing. He even toured for a while in a production of *Uncle Tom's Cabin*, but he never received his shot at Sullivan or even Corbett after the latter had won the title. Jackson took heavily to the bottle and returned to Australia where he died in 1901. (Author's collection.)

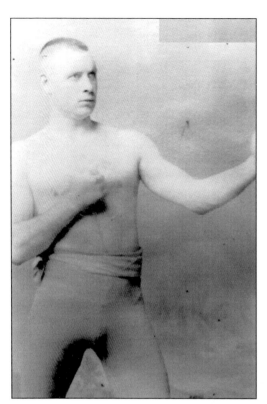

JACK MCGEE, THE FIGHTER'S FIGHTER. Jack McGee was a native of Boston's West End. He came from a family of fishermen and worked as a stevedore on the Boston waterfront for many years before, during, and after his boxing career had run its course. He was a fighter's fighter who would box anyone, white or black, anytime the opportunity presented itself. (Ben Hawes's collection.)

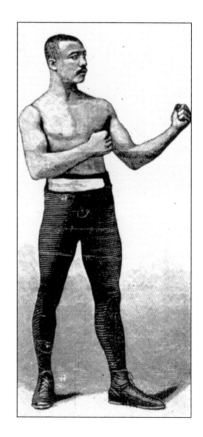

THE "BOSTON BLACK," 1891. Ed Binney, the "Boston Black," worked as a coal heaver for the Austin C. Wellington Company in Boston when he first took up prizefighting in 1886. Binney earned $10 a week for his work with the coal cart. Shortly after this picture appeared in the *Police News* on November 14, 1891, Binney captured the Colored Middleweight Championship of America by defeating Harris Martin, known as the "Black Pearl," in 25 rounds. He earned $1150 for his victory. (Author's collection.)

PATSY SHEPPARD. Patsy Sheppard was a middleweight fighter whose career was unremarkable. He hailed from Boston's West End. (Ben Hawes's collection.)

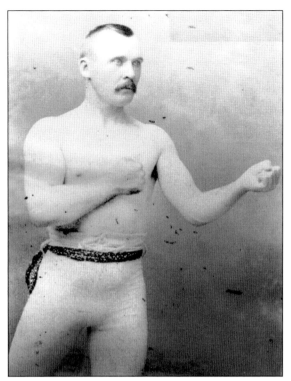

MARCELLUS BAKER IN A FIGHTING POSE. Marcellus Baker was born in Maine but made Boston his home as early as 1879. An old-school bareknuckle fighter, Baker counted among his rivals fellow Bostonians Jack Havlin and Billy Frazier. Never a champion but always a tough proposition, Baker was active from the end of the Civil War through 1892. He died in the spring of 1892 while still actively participating in ring contests. (Ben Hawes's collection.)

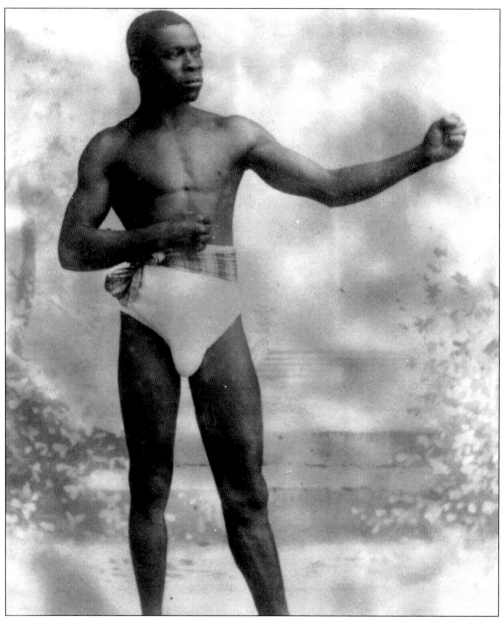

BOB GREEN, THE "BLACK SPIDER," 1895. Bob Green, whose ring sobriquet was the "Black Spider," was 128 pounds of pure aggression. A native of Boston's West End, Green's life was as violent outside of the ring as it was inside the squared circle. Green was a formidable boxer as well as a frequent street brawler who was stabbed no less than five times in four years and accused of shooting a man over a hand of cards. However, for all his negative traits, Green was a smart businessman who turned his boxing profits into a small fortune. An avid baseball player, he often organized games between his team, the Spiders, which counted George Godfrey as one of its pitching staff, and Dick O'Brien's nine, also made up of mostly pugilists. The Black Spider was also Boston's, and possibly the nation's, first black promoter to stage bouts between black and white fighters. In his middle age, Green reformed his evil ways and became an ordained minister. (Ben Hawes's collection.)

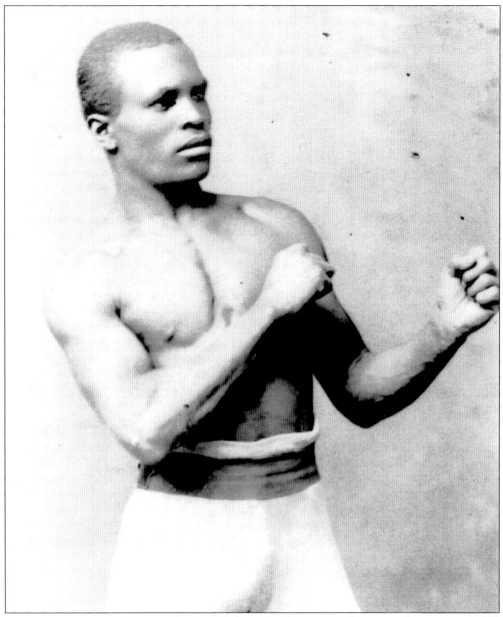

JOHNNY BANKS, THE "DARKEY WIZARD." Johnny Banks came to Boston in the winter of 1888 to fight Ed Binney for the colored middleweight title. The two were friendly and agreed before the bout that they would take it easy on one another and be satisfied with a draw verdict. The bout took place at the Pelican Club and was uninteresting from the start. At the end of the 13th round, the referee declared the bout a farce and announced that both boxers' purses would be withheld. Binney and Banks then agreed to fight legitimately for 3 more rounds with a winner to be determined at the end of those 3 rounds. Binney presented himself to the members of the club and announced from the ring's center, "Mine and mister Banks's agreement is done. We will now fight in earnest." Salvaging the show and their purse money, Binney and Banks fought at a quick pace to the pleasure of the crowd. Binney was declared the winner. (Author's collection.)

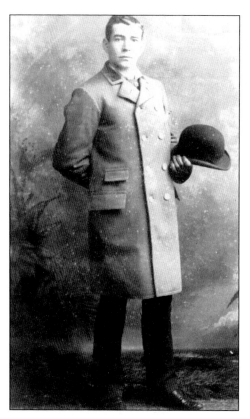

IKE WEIR, THE "BELFAST SPIDER," 1890. As a boy, the Belfast born Ike Weir had aspirations to be a priest. Instead, the lure of easy money led him to the horse track where he became a jockey at the tender age of 13. At 15 he joined a song-and-dance troupe where he learned to act, play the piano, recite poetry, and perform comedy routines while standing on his head. His greatest skill however lay in his ability to throw punches. He came to Boston in 1886 and fought out of his adopted hometown for the remainder of his career. Never weighing more than 120 pounds, Ike Weir fought for the world featherweight title in 1894 but was knocked out by Billy Murphy in 14 rounds. (Ben Hawes's collection.)

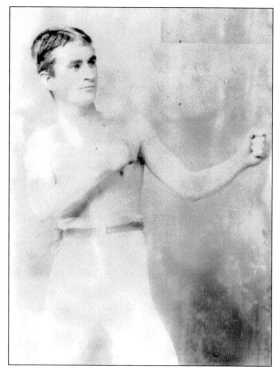

JAMES BURKE. James Burke was a speedy lightweight from South Boston who never reached the championship level. (Ben Hawes's collection.)

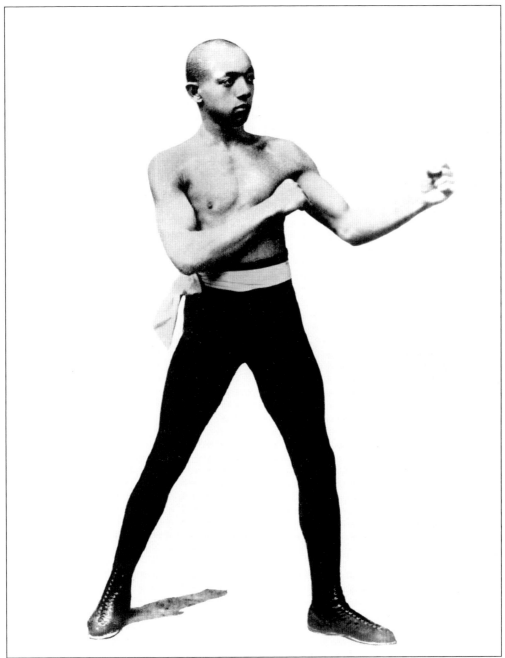

GEORGE DIXON, "LITTLE CHOCOLATE," C. 1888. The baby-faced George Dixon, also known as "Little Chocolate," quit school as a youngster to become a photographer's assistant. His interest in boxing was sparked by the conversations he would have with the many pugilists who visited his studio to have their portraits taken. Dixon, who never weighed more than 120 pounds, began boxing at the age of 16 and fought well over 300 bouts in a career that spanned 20 years. He was elected into the Boxing Hall of Fame in 1992. (Author's collection.)

GEORGE DIXON, 1891. Little Chocolate was the first black world champion in any sport. Born in Nova Scotia, Dixon became a resident of Boston in 1887 when he came to Bean Town to further his boxing career. After a few impressive victories, Dixon signed a contract with Tom O'Rourke, a manager and promoter from Boston who ultimately steered Dixon to the height of fame and prizefighting glory. (Author's collection.)

TOM O'ROURKE. Tom O'Rourke discovered George Dixon and, in less than two years, secured him a title match. In the 1890s, a black fighter's chances at a world championship match were few and far between, and O'Rourke's ability to steer Dixon into a championship match fully illustrates his skill as a negotiator and a publicity man. O'Rourke was not a scrupulous man, and he worked Dixon rigorously. Many claimed that Dixon had over 1,200 bouts in his career. (Author's collection.)

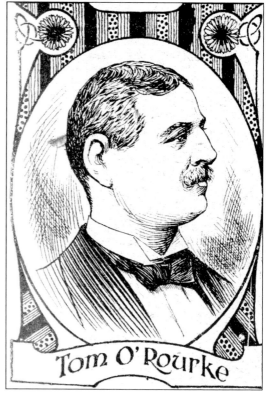

HOWARD THEATRE ADVERTISEMENT FOR THE "ROSEBUD," 1894. Walter Edgerton, the "Rosebud," was one of the fighters who profited from Dixon's exhibition schedule. After knocking out Dixon in an 1894 bout in Philadelphia, the Rosebud made his own exhibition tour using his victory over the famous and popular Dixon as publicity. It worked well in Boston where crowds packed the Howard Theatre in Scully Square for seven straight days to watch the "man who licked Dixon" go through a routine of skipping rope, sparring, and a descriptive re-enactment of his knockout over Little Chocolate. (Author's collection.)

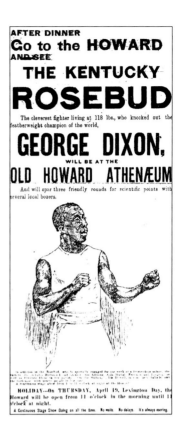

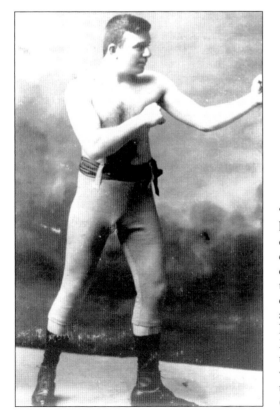

"YOUNG GRIFFO." Albert Griffiths, better known as "Young Griffo," was a product of Australia. Today, he is considered one of the great wizards in boxing history. He came to America and challenged Dixon, the result being one of the great battles of the time. They met for the first time at the Casino Athletic Club in the South End on June 29, 1894, which ended with a 20-round draw. Future battles between the two men did little to settle the matter of who was better. They met a total of three times, all of which ended in draw decisions. (Ben Hawes's collection.)

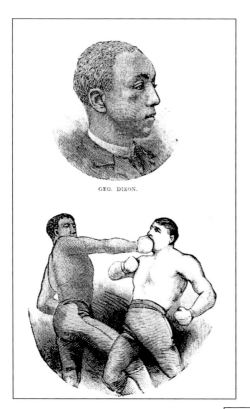

GEO. DIXON.

GEORGE DIXON VERSUS NUNC WALLACE, 1890. George Dixon and Tom O'Rourke traveled to London in the summer of 1890 to challenge Nunc Wallace for the world featherweight title. Dixon had previously fought a 70-round draw with Cal McCarthy in Boston for the American championship, and in meeting Wallace, who claimed the English title, had hoped to claim the world title. Dixon clearly demonstrated his superiority and knocked out Wallace in 18 rounds, claiming the world title in the process. (Author's collection.)

A SKETCH OF JOHN T. GRIFFIN. The Braintree born John T. Griffin was a clever featherweight who fought some of the best men of his weight and generation. In his decade-long career, Griffin met several world champions including George Dixon, Solly Smith, and George Lavigne. Unfortunately, Griffin failed in his biggest moments, losing in all three contests. (Author's collection.)

"STONEWALL" BOB ALLEN. Bob Allen, who went by several nicknames, including "Stonewall" and "Lowdown," had a long and interesting career. He was not born in Boston but was based there and in parts of Maine for the majority of his 25-year career. In 1896, Allen was shot at point-blank range three times in the head and robbed of $400 when he became involved in an argument over a craps game in Cambridge. Miraculously, Allen survived and fought on for another 13 years. In his later years, Allen became an evangelist. (Bob Carson's collection.)

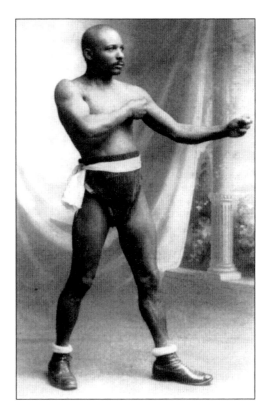

PROFESSOR ANDY WATSON, 1896. Andy Watson, who was born in Georgetown, British Guiana, came to Boston as a sailor in 1890. He found more money was to be made in the prize ring and decided to stay in the states, beginning his fistic career in early 1892. With his earnings, he bought a two-story building in the Bowdoin Square section of Boston's old West End where he promptly opened an athletic club. His gym quickly became known as one of the best in the city and was frequented by not only some of the best boxers in the city but also by some of Boston's upper-crust citizens as well. The popularity of Watson's gym and his fine reputation as a trainer led to his appointment as chief boxing instructor at Harvard in 1903. (Author's collection.)

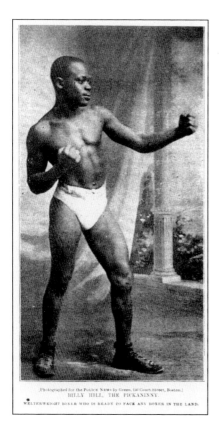

BILLY HILL MULDOON'S PICKANINNY. Made famous when he toured with William Muldoon's famous traveling troupe of boxers taking on all comers, William Hill was born in Washington, D.C., but called Boston his home for many years. The "Pick," as Hill was known, was a well-liked performer and a tough proposition as a boxer. He fought all the black stars of Boston, including John Butler, Andy Watson, Bob Green, and Bob Allen. He was a familiar site on Washington Street where he would go through his training exercises in the midst of full crowds for money, which was deposited into a hat as it was passed around. (Bob Carson's collection.)

MARTIN FLAHERTY. Martin Flaherty and his brother Maffit hailed from Lowell. Both made careers as prizefighters, but the younger and lighter Martin could be considered a greater success. Martin fought from weights ranging from 118 up to 130 pounds and opponents such as George Dixon, Solly Smith, Andy Watson, Tim Kearns, Dal Hawkins, Joe Gans, and Oscar Gardner. He was never a world champion, but in a career that lasted from 1888 through 1909, he fought the best men available and was seldom outclassed. (Ben Hawes's collection.)

JACK HAVLIN. Jack Havlin, who was known as the "Miniature Morrisey" (after the famous bareknuckle fighter of an earlier era), was born, bred, and laid to rest in Boston. He was a tenacious performer with an odd career. After a loss to Patsy Kerrigan in 1886, Jack retired and sighted that he had seen enough of the fight game but returned to action almost a year later and fought until 1894. (Ben Hawes's collection.)

JOHN WATSON. John Watson was a tough performer but gained more attention as a trainer than as a fighter. He was also a well-respected bicycle racer, holding at one time the 10-mile championship of New England. (Ben Hawes's collection.)

DAVE SULLIVAN, 1896. Dave Sullivan was born in Ireland but fought out of Boston for many years. He was a favorite among the Irish in Bean Town and did a great deal of his early fighting in South Boston. (Ben Hawes's collection.)

"SPIKE" SULLIVAN, 1896. Dave's brother, William "Spike" Sullivan, was also born in Ireland. Slightly larger than his brother, Spike's slashing style won him fans wherever he appeared. The many benefits held in his honor were a testament to his popularity in Boston and the surrounding area. In 1896, the Kirland Club of Lynn, the Casino Athletic Club, and the South Boston Boosters all held benefits for Sullivan. The total yield for Spike was well over $1,000, a princely sum in those days. (Ben Hawes's collection.)

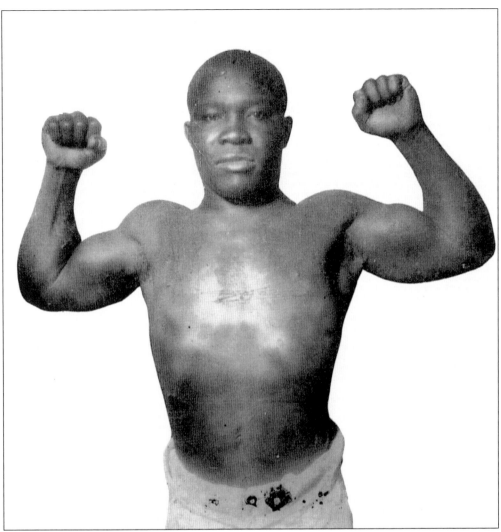

JOE WOLCOTT FLEXES. The five-foot-one-inch tall Joe Wolcott was born in Barbados but grew up in the South End. The very epitome of a "human fire hydrant," "Barbados Joe" was one of the premier welterweight champions in the history of boxing. Wolcott was a ferocious puncher and possessed an underrated defense. After an unsuccessful attempt against champion "Mysterious" Billy Smith in 1898, he won the welterweight title from Rube Ferns in the winter of 1901. He held the title for close to 4 years and remained a dangerous opponent for another 10. Wolcott was a 150-pound giant-killer who fought middleweights, light heavyweights, and even heavyweights. Perhaps one of his most celebrated victories was his seven-round knockout of heavyweight contender Joe Choyinski on February 23, 1900. (Author's collection.)

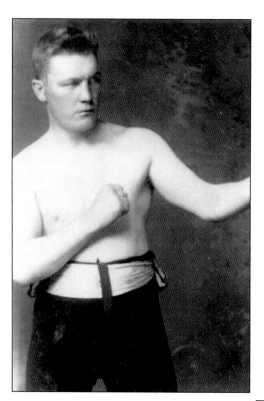

DICK O'BRIEN. Dick O'Brien was born to be a fighter. At only 12 years of age, he fought his first professional bout in Lewiston, Maine. He won the match for a purse of 25¢ and never looked back. In a career that spanned 2 decades, O'Brien met the best men in his class. He held the middleweight title in New England for 5 years and fought several world champions including Joe Wolcott and the infamous "Kid" McCoy. (Ben Hawes's collection.)

CHARLES "KID" MCCOY. Norman Selby, better known as "Kid" McCoy, was one of the more popular and interesting fighters of the decade that preceded the turn of the 20th century. He won the middleweight title in 1897 by defeating Dan Creedon in 15 rounds and was the inventor of the corkscrew punch. He came to Boston on several occasions to show his wares and was always a tremendous draw. Perhaps his finest bout in Bean Town was his 6-round victory on a foul over Mysterious Bill Smith. (Ben Hawes's collection.)

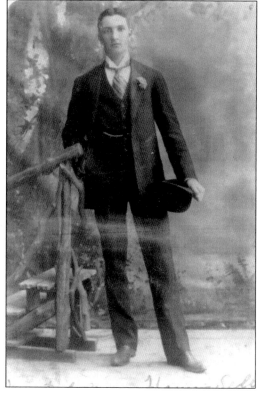

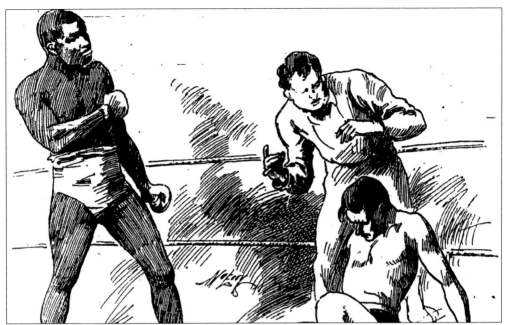

JOE WOLCOTT KNOCKS OUT DICK O'BRIEN, 1895. This pencil drawing depicts Joe Wolcott's one-round destruction of the sturdy and popular Dick O'Brien at the Cribb Club on August 28, 1895. O'Brien gave Wolcott a stiff contest less than a year prior to their Cribb Club meeting but made a serious error in judgment before their second encounter. Thinking he could throw Wolcott off his game by insulting him, O'Brien, while passing Wolcott on the way into the club, began singing a racist tune of the time. The song enraged Wolcott, but it did not have the affect that O'Brien desired. When the fight took place later that evening Wolcott knocked out O'Brien in less than two minutes. (Author's collection.)

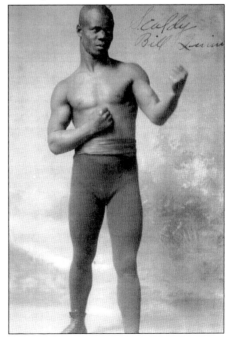

"SCALDY" BILL QUINN. Bill Quinn came from the coal regions of Pennsylvania to challenge Joe Wolcott for the welterweight title. The pair met at the Woburn Athletic Club on May 29, 1896. In a contest that was described as "one of the fiercest and most evenly contested bouts of the last 20 years," Quinn matched Wolcott punch for punch and earned himself a reputation as a tough contender. Unfortunately, Quinn's reputation was soiled when 5 months later the pair met again, and Quinn was knocked out in 17 rounds. (Bob Carson's collection.)

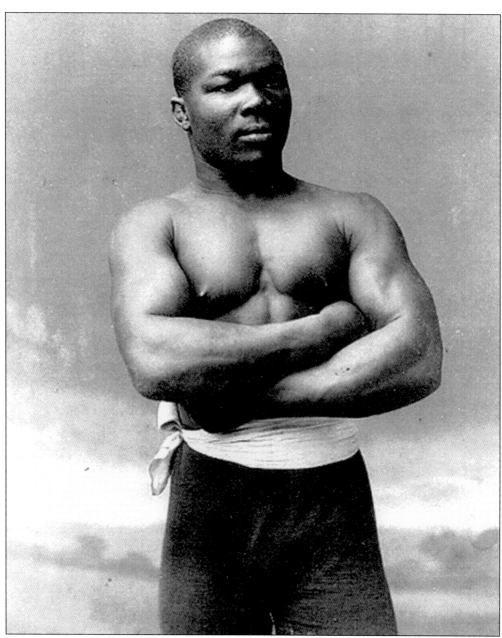

Joe Wolcott, 1897. Wolcott lost his welterweight title on a bogus disqualification to Aaron Brown, known as the "Dixie Kid," in 1904 at San Francisco but remained a viable opponent for several years. In 1906, he attempted to regain the title when he met Charlestown's William "Honey" Mellody in Chelsea but was unsuccessful and lost a decision after five rounds. Another crack at Mellody resulted in a knockout loss, and Wolcott never seriously contended for the title again. His career continued for another five years, but old Barbados Joe was by then only a shell of his former self. Wolcott served as a porter at Yankee Stadium in New York for several years during the 1920s but seemed to have disappeared thereafter. In 1935, an unidentified man, who later was recognized as Wolcott, was found dead on the roadside in Massillon, Ohio. Wolcott was inducted in the Boxing Hall of Fame in 1991. (Bob Carson's collection.)

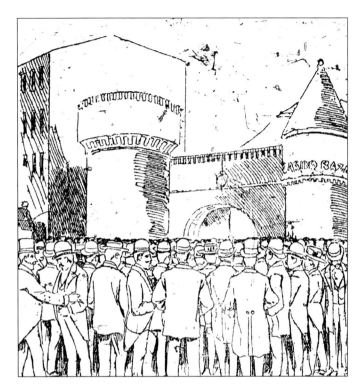

THE CASINO ATHLETIC CLUB ON TREMONT STREET, 1891. A gathering mills around outside the Casino Athletic Club on Tremont Street in Boston's South End. During the 1890s, the Casino Athletic Club was the site of many of the more important battles that took place in Boston. Many residents of the South End did not like the club in the middle of their neighborhood and on more than one occasion attempted to have it closed. (Author's collection.)

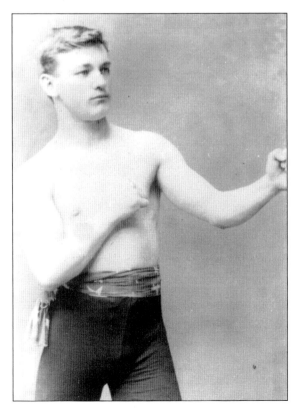

MIKE SEARS IN A FIGHTING POSE. Mike Sears, a 125-pound fighter, was a native of Maine but did a great deal of fighting in Boston. (Ben Hawes's collection.)

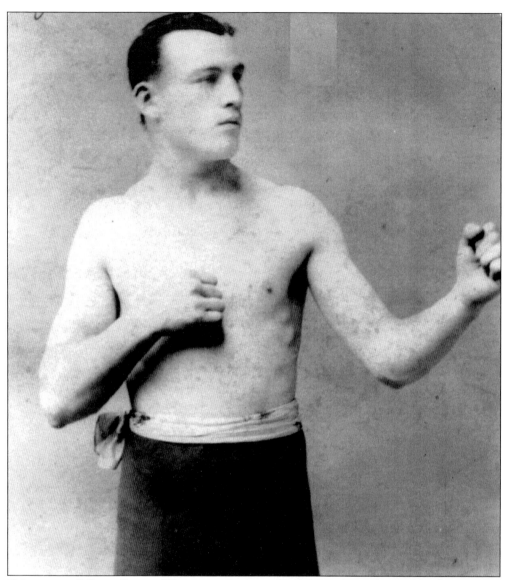

"MYSTERIOUS" BILLY SMITH. Where exactly Amos "Billy" Smith was born is the first mystery about the fighter. Some sources say Eastport, Maine, and others say Boston. Regardless, Smith will always be remembered as one of the fiercest fighters who ever roamed the earth. Using any and every method possible, Smith fought to win. Captain Cooke of the *Police News* dubbed Smith "Mysterious," but "Killer" might have been a better appellation. Smith won the vacant welterweight title against Danny Needham in 1892 in San Francisco. He returned east early the next year and settled in Lynn where his 18-year-old wife, Minnie, died of blood poisoning shortly thereafter. Smith lost his welterweight title to Tommy Ryan in 1894 and began fighting in the middleweight division. In 1896, he met Kid McCoy in Boston for the middleweight title but was disqualified in the sixth round for foul tactics. Not to be denied, in 1898 Smith again challenged for the welterweight title and defeated Matty Mathews in 25 rounds to claim the championship. He defended the title against a number of opponents including Joe Wolcott and George Lavigne and maintained hold of his laurels for close to two years. Matty Mathews ended Smith's reign in 1900. (Ben Hawes's collection.)

FRANK THE "HARLEM COFFEE COOLER," 1895. The "Harlem Coffee Cooler," as Frank Craig was called, came to Boston on July 16, 1894, in order to take on the famed Peter Maher. The Cooler was coming off a string of five straight knockouts and eight straight victories and seemed well fit to give Maher a stiff contest. In the first round, the Cooler landed some stiff shots but was overwhelmed by the larger Australian and knocked out cold in the second round. (Author's collection.)

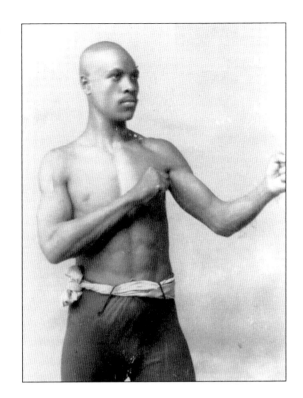

JOHN E. BUTLER, 1894. John E. Butler hailed from Lynn, Massachusetts, where he was extremely well respected. A lightweight of high skill, John fought almost exclusively in Boston and Lynn. His fierce rivalries with Andy Watson, Tommy Chandler, and Billy Hill were legendary around Boston. (Author's collection.)

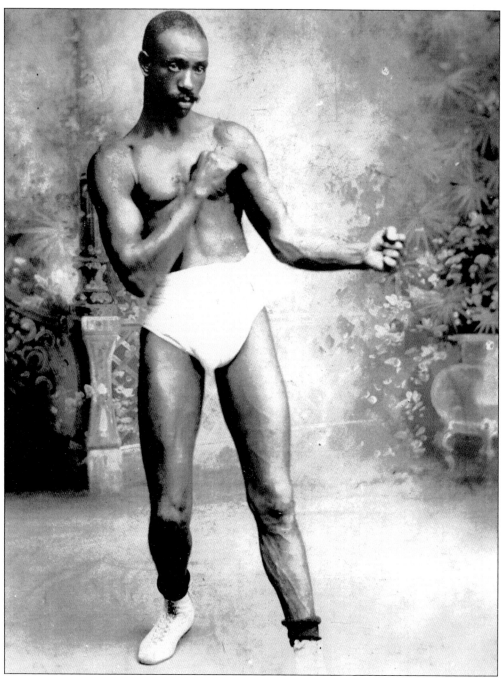

BOBBY DOBBS IN A FIGHTING POSE. One of the great lightweights of all time, Bobby Dobbs spent a great deal of time in Boston but fought there only once. In 1895, Dobbs came to Bean Town where his reputation preceded him. Unable to find a lightweight willing to meet him, Dobbs agreed to a match with New England middleweight champion Dick O'Brien. Dobbs fought brilliantly, and the locals soon learned that his reputation was well earned. His lack of weight told in the latter rounds, and by the 18th frame, he was badly used up. In the middle of the round, he held up his glove and proclaimed that he was done. (Author's collection.)

GEORGE BYERS IN A FIGHTING POSE, 1896. Another of the great black Canadian fighters who came to Boston, George Byers lived Bean Town until his death in 1937. A skilled boxer with better than average power, Byers was a middleweight who often met larger men. In 1899, he was considered the top contender for Tommy Ryan's middleweight crown. Ryan often stated that he would not fight the Bostonian because he was black but defended his title that same year against the less formidable black fighter Frank Craig. In September of that year, Byers career took a drastic turn for the worse when he took a dive against Tommy West in Coney Island. He rebounded and went on to win the colored middleweight and heavyweight titles but never got the world title shot that he so richly deserved. (Author's collection.)

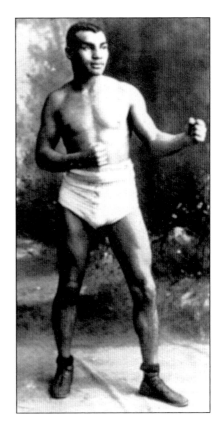

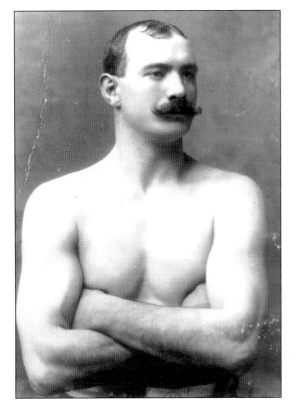

PETER MAHER THE "IRISHMAN." Peter Maher, the "Irishman," was one of the more spectacular fighters of his time. He came to Boston in May 1894 to take on George Godfrey. A few days before the match, the *Boston Post* quoted George, who trained for the bout at Revere Beach, as saying, "I am old but still a tough time for the likes of Peter Maher." The two met at the Casino Athletic Club and Godfrey was outclassed from the start. Maher ended his work in the sixth round with a fierce combination that dislodged several of Godfrey's teeth. (Ben Hawes's collection.)

JOHN L. SULLIVAN RETIRES. After Sullivan lost to James Corbett, he never fought again. He remained in the public eye in a number of different roles. He had stints as a boxing correspondent for the *New York Times*, refereed a number of bouts, and appeared in several vaudeville and stage productions, the most successful being, *The Man from Boston*. The Boston Strong Boy, who had become known for his heavy drinking, gave up the bottle and turned to a career as a temperance speaker. (Ben Hawes's collection.)

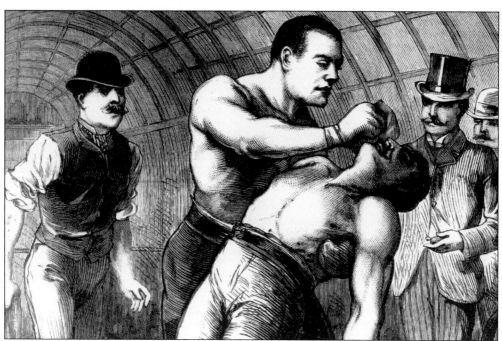

JOHN L. SULLIVAN ASSISTS PADDY RYAN. Sullivan's charisma changed boxing forever. He turned himself from the scourge of society into a respectable athlete. His enduring name is today, almost 100 years since his passing, still recognized by even casual fans. (Author's collection.)

Two

THE BOSTON TAR BABY
"That Baby is Out for Keeps!"

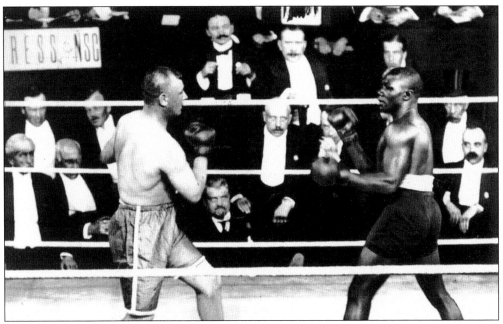

SAM LANGFORD VERSUS "IRON" HAGUE, 1909. Sam Langford sizes up English champion William Hague, also known as "Iron Bill," at the National Sporting Club in London. In the fourth round, Hague caught Langford with a fearful right-hand smash on the ear, which sent him sprawling. Langford, a bit dazed, scrambled to his feet while rubbing his ear, a look of shock owning his expression. Iron Bill recklessly moved in for the kill, and Langford unleashed a booming right hook that landed flush on the Englishman's jaw. Hague dropped like a felled tree. Langford still looked a bit confused when he gazed over at Hague's corner where he lay. Langford leaned over the ropes and looked directly at Hague's corner men as he calmly stated, "Say boys. He ain't gonna get up. That baby is out for keeps." (Author's collection.)

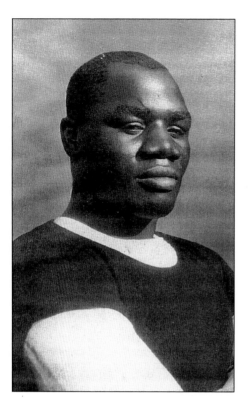

SAM LANGFORD THE "BOSTON TAR BABY," 1914. Perhaps the greatest of them all, Sam Langford, the "Boston Tar Baby," began his career in Boston in 1902 and fought professionally for over 25 years. Born in Weymouth, Nova Scotia, in 1886 (by some reports 1880 or 1883), Langford fled home at a young age and lived as a hobo for many years. He found his way to Boston where his career as a fighter began at Joe Woodman's Lennox Club. (Dave Bergin's collection.)

SAM LANGFORD IN A FIGHTING POSE, c. 1908. After a brief amateur career, Langford turned professional as a lightweight in 1902. Still a teenager in 1903, with little more than 20 bouts under his belt, he was matched with hardened veterans like Bob Allen, Billy Jordan, John Butler, and Andy Watson. He defeated them all and, by the end of the year, was fighting men like Joe Gans, the lightweight champion of the world, and the slick, dangerous Jack Blackburn. Langford's early success against such stiff competition branded him as a man to be reckoned with, and he soon found opponents harder and harder to come by. (Author's collection.)

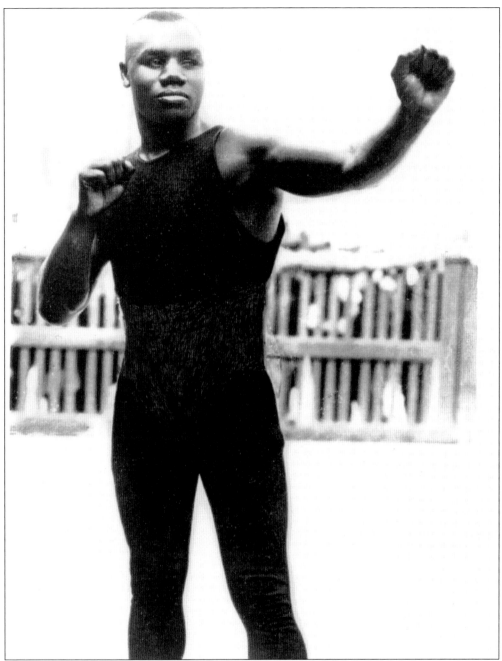

SAM LANGFORD, C. 1911. In his long career, Langford, who began at 130 pounds, fought in every division up to heavyweight. In 1906, he took on Jack Johnson, future heavyweight champion of the world, in Chelsea. Outweighed, outsized, and out slicked, Langford took what he described as, "the only real beating of my life." Langford spent the better part of his career trying to gain a rematch with Johnson, who after he had won the championship steadfastly refused to meet the Bostonian. "What is it that I would gain by fighting Sam?" Johnson quipped. He sighted that the boxing world did not want to see two black men fight one another for the heavyweight championship. (Ben Hawes's collection.)

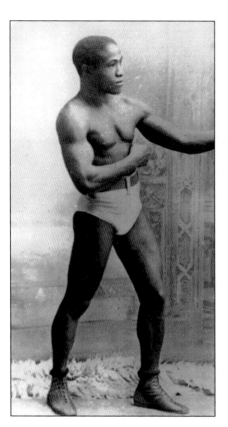

"YOUNG PETER JACKSON," C. 1900. Sim Thompkins, named "Young Peter Jackson" because of his facial resemblance to the famous Australian heavyweight, was one of the toughest welterweights in the business around the turn of the 20th century. He and Langford staged six battles in all, and Langford had the clear advantage in all but one bout. Jackson fought in Boston frequently and met men such as Jack "Twin" Sullivan, Larry Temple, and Charley O'Rourke. Young Peter also met Joe Wolcott on several occasions, once knocking the former champion out in four rounds at Baltimore in 1904. (Author's collection.)

GEORGE BYERS, C. 1898. Sam Langford was once asked how he learned the finer points of the fighting game. He responded that he knew close to nothing about proper fighting before meeting Boston veteran George Byers. "I was more or less a street fighter when I met George Byers. I was fighting with another boy and having my way with him on Washington Street when a crowd gathered and became hostile at my accosting the white youth. When the crowd was close to mobbing me a fine-looking gentleman stepped forward and silenced them. It was George Byers. He told me that I had potential to be a real fighter but needed some schooling. I learned most of what I know about real fighting from George." (Author's collection.)

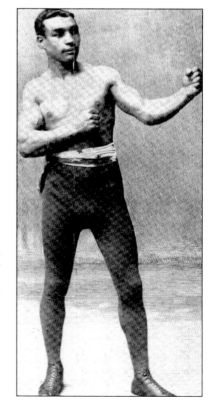

An Al Delmont Mecca Cigarette Card, 1911. Al Delmont was born in Naples, Italy, but came to the United States as a boy and settled in Boston. His career began when he was 18 years old and was guided by the able Joe Woodman. Delmont, a featherweight, fought professionally for over 15 years and was rarely beaten decisively. He and Sam Langford were very close friends. He traveled with Langford to England in 1907. (Author's collection.)

A "Young Donahaue" Mecca Cigarette Card, 1911. A native Bostonian born in 1885, Phil "Young Donahue" Powers, fought as a lightweight from 1903 until 1912. (Author's collection.)

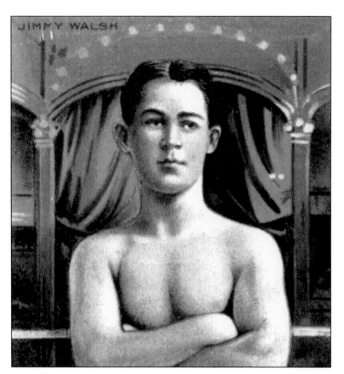

A JIMMY WALSH MECCA CIGARETTE CARD, 1911. Born in Newton in 1886 Jimmy Walsh was one of the better bantamweights of his generation. He began his professional career in 1901 when he was merely 15 years old and remained active until 1913. (Author's collection.)

A JIMMY WALSH FIGHT POSE, c. 1906. Jimmy Walsh claimed the World Bantamweight Championship in 1905 when he defeated England's Digger Stanley at Chelsea in the fall of that year. Walsh never took his title too seriously, and it lapsed into obscurity until 1908. (Author's collection.)

LARRY TEMPLE, THE "BLACK CYCLONE," 1903. The "Black Cyclone," as Larry Temple was known, was brought to Boston by Tom O'Rourke in December 1903 to fight Joe Wolcott. O'Rourke, after an ugly breakup with Walcott, developed Temple with the purpose of taking Walcott's crown. Temple appeared in Boston earlier in the year and impressed a great deal of the locals by beating Young Peter Jackson and Charlie Haghey. O'Rourke settled Temple on a farm in Connecticut where Temple dutifully trained day in and day out. The two warriors met on December 29th at the Criterion Club. Wolcott was the betting favorite by a wide margin, but it took 15 brutal rounds for him to demonstrate his superiority. Temple's showing did a great deal to further boost his stock, but he had to wait four years to exact his revenge. He met Wolcott in Boston again in the summer of 1908 and knocked out the old war horse in the 10th round, but ironically, Tom O'Rourke was no longer his manager. (Author's collection.)

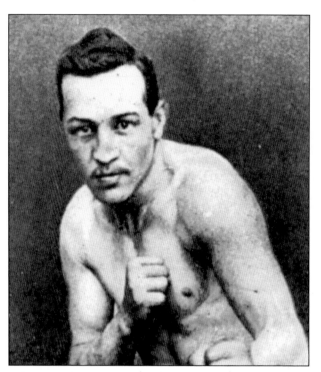

"Honey" Mellody, 1911. William J. "Honey" Mellody was born in Boston's North End in 1884. Although not a large boy, he built up strong shoulders and hands through an apprenticeship as a coppersmith where he worked for the better part of three years prior to becoming a fighter. Mellody won and lost the welterweight championship in the course of seven months during 1907. After his boxing career had ended, he worked as a ship lifter at the Charlestown Navy Yard for several years and published a book detailing his many adventures as a fighter. Mellody died of complications due to pneumonia in his home on March 1, 1919. (Author's collection.)

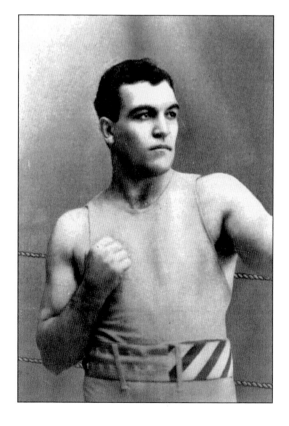

James Jeffries, c. 1904. James Jeffries, heavyweight champion, was a native of San Francisco and made few trips to the East Coast while he was champion. In December 1903, he showed up in Boston and appeared for one week at the Howard Theatre with his sparring partner Joe Kennedy. Jeffries went through the standard fair and retold stories of his greatest bouts, then skipped rope, and then sparred a few rounds with Kennedy. (Ben Hawes's collection.)

MIKE "TWIN" SULLIVAN IN A FIGHTING POSE, C. 1907. Mike Sullivan hailed from Cambridge, Massachusetts, and claimed the welterweight title of the world when he defeated Charlestown's Honey Mellody in 1907 at the Armory Athletic Club in Boston. Sullivan relinquished his title less than a month later when he outgrew the welterweight class. His twin brother, Jack, was also a high-class fighter who campaigned in the middleweight class. (Author's collection.)

HENRY JOHNSON HALL IN A FIGHTING POSE, c. 1907. Henry Johnson Hall was a native-born Bostonian who won the National Amateur Middleweight Championship in Boston in April 1908. In the final match of the tournament, Hall was so dominant that his opponent bit him three times in the final round. Johnson served as a boxing instructor in Newport, Rhode Island, and had a rather unspectacular professional career. (Chuck Hasson's collection.)

A GEORGE GUNTHER BUST, 1905.
George Gunther began his professional career with an amazing 41 straight victories, all by knockout. He arrived in Boston in the fall of 1904 from Australia, via Seattle, and was immediately matched with John Butler who he easily dispatched in five rounds. He remained in Bean Town for another year and a half where he took on the likes of Charlie O'Rourke and Sam Langford. After moving to Europe in 1909, George continued to box until 1914 when he joined the French foreign legion and saw action on several fronts. He returned to the United States in 1916 and ended his career fighting out of Pittsfield, Massachusetts. (Dave Bergin's collection.)

SAM MCVEY, C. 1910. One of Sam Langford's greatest and most frequent opponents was Sam McVey. Langford and McVey met 15 times: some fierce brawls and others nothing more than slow waltzes. The two Sams became so familiar with one another that they were often accused of staging their bouts. McVey, who was built like Hercules, died of pneumonia in 1921. (Dave Bergin's collection.)

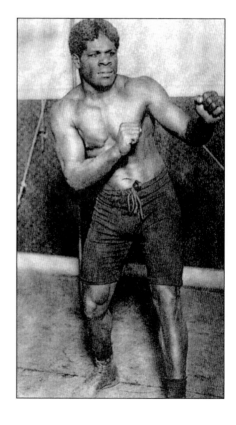

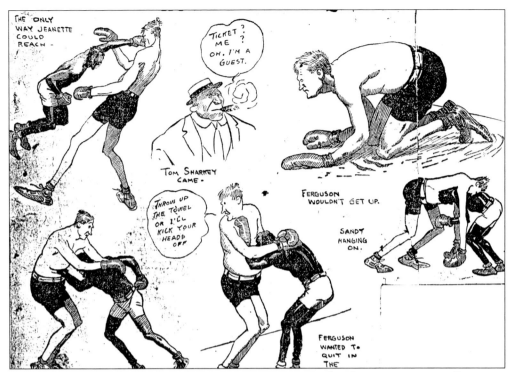

A Cartoon of Joe Jeannette versus Sandy Ferguson. Joe Jeannette came to Boston in September 1908 to take on John Sandy Ferguson. Ferguson, who was known as the "Problem Child," was an uncertain entity. An immensely talented natural athlete, Ferguson did not always train to the fullest and was often out of shape when he entered the ring. When tackling the lighter Jeannette, Ferguson underestimated the skill and power of his rival. The two met four times, and Jeannette owned the series, winning three out of the four contests. In the last meeting, Ferguson was stopped in the seventh round after taking a severe beating. (Ben Hawes's collection.)

Joe Jeannette in a Fighting Pose. Joe Jeannette was a handsome family man who enjoyed many athletic pursuits. He was active in an early professional basketball league and was known to take the field frequently in semi-professional baseball games in his native New Jersey. He fought in Boston frequently. (Author's collection.)

A BELFIELD WOLCOTT BUST, 1904. The less famous of the Wolcott brothers of Boston, Belfield spent most of his career in the shadow of his brother Joe, welterweight champion. It was not uncommon for the two to be seen sparring together on the lawn of their summer camp in Malden, Massachusetts. In some instances, as many as 200 people could be found standing in and around their property, getting free admission to what the *Boston Post* called "some of the better fighting to be seen in Boston." (Author's collection.)

JACK JOHNSON, C. 1904. Jack Johnson, not yet a champion when this photo was taken, *c.* 1904, learned a great deal of his technique from Joe Wolcott. The two became friendly in 1896 when Johnson, at the time a fledgling mitt-artist, came to Boston in an attempt to jump-start his career. Unable to obtain bouts, he took a job as a sparring partner for Wolcott, the future welterweight champion of the world. (Author's collection.)

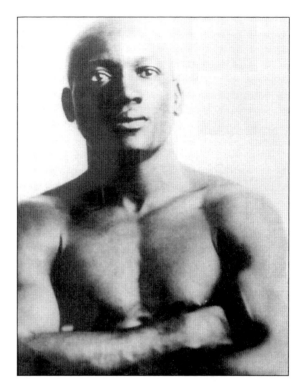

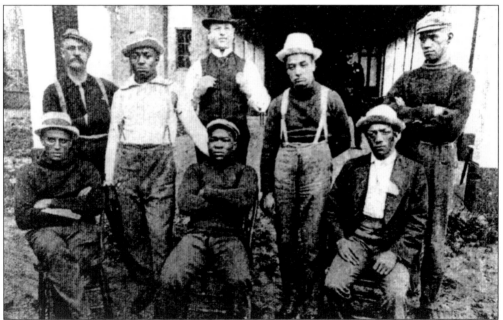

JOE GANS, GEORGE DIXON, AND JOE WOLCOTT. The first three black world champion boxers the world has known gather at Professor Jimmy Kelly's camp on Staten Island. Shown, from left to right, are (front row) Joe Gans, Joe Wolcott, and George Dixon; (back row) Jimmy Kelly, Jim Ashe (of Boston), Al Herford (manager of Gans), unidentified, and Harry Lyons. (Ben Hawes's collection.)

JOE GANS, THE "OLD MASTER." The lightweight champion Joe Gans came to Boston in December 1903 to pick up what he must have thought would be an easy paycheck. Instead, he ran into 17-year-old Sam Langford. Langford had only been fighting professionally for a year and a half and figured to be easy pickings for the great Gans. Gans was so unconcerned with Langford that he spent the night before the bout engaged in an all-night poker game. His confidence was shattered when Langford outmuscled and out-hustled the lightweight champion and won a decision after 15 rounds. Langford weighed in over the lightweight limit and, therefore, was not able to claim Gans's championship. (Author's collection.)

JOE GANS, LIGHTWEIGHT CHAMPION OF THE WORLD, 1904. Joe Gans first appeared in Boston in 1896 when he flattened Jim Kennard in 5 rounds. He returned in 1902 to defeat Charley Seiger in 10 rounds and then made his final appearance against Langford the next year. Gans died in 1910 of tuberculosis. (Author's collection.)

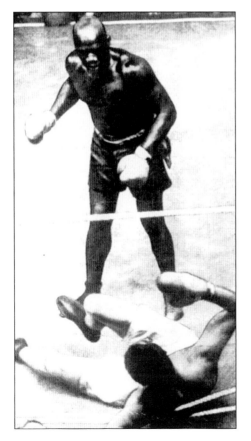

SAM LANGFORD VERSUS BILL LANG, 1911. Promoter Hugh "Huge Deal" McIntosh, who later made a fortune as a newspaper magnate, brought Sam Langford back to London in February 1911 to take on his new protégé: Bill Lang, the Australian bushman. McIntosh thought Langford was made for Lang and figured a victory over the popular and well respected Tar Baby would boost his fighter's stock. Huge Deal McIntosh paid Langford $15,000 and outfitted both fighters in novelty white gloves. In the end, the fight was a mismatch and the six-foot-tall, 196-pound Lang was cannon fodder for the 165-pound Langford. After taking a fearful beating, Lang struck a foul blow and was disqualified in the sixth round. (Dave Bergin's collection.)

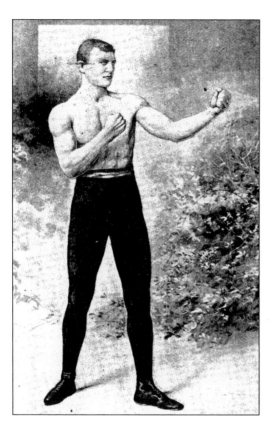

GEORGE GARDNER IN A FIGHTING POSE, 1901. George Gardner, a native of Lowell, won the light heavyweight title on Independence Day in 1903 with a 12-round knockout of Jack Root. He lost the title less then four months later when he lost a 20-round decision to the legendary Bob Fitzsimmons. Gardner's two brothers, Billy and Jimmy, were also fighters. His sister married the famous middleweight Joe Thomas of Beverly. (Author's collection.)

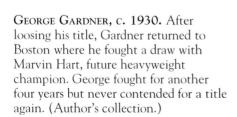

GEORGE GARDNER, C. 1930. After loosing his title, Gardner returned to Boston where he fought a draw with Marvin Hart, future heavyweight champion. George fought for another four years but never contended for a title again. (Author's collection.)

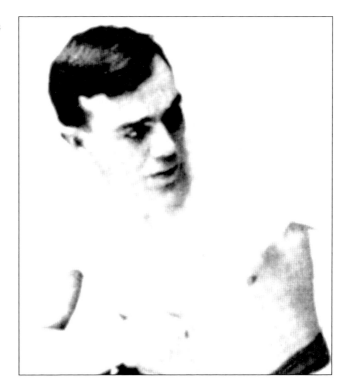

JIMMY GARDNER IN A FIGHTING POSE, 1907. Jimmy Gardner claimed the welterweight title in 1908 after defeating Jimmy Clabby. Gardner was never universally recognized as a champion and only officially defended his title once. He was a remarkable fighter nonetheless and lost only four bouts in his first 11 years as a professional. (Author's collection.)

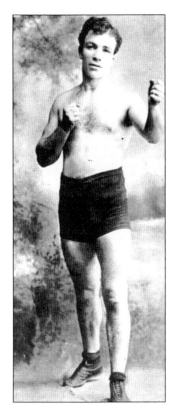

MIKE GLOVER, 1913. Mike Glover died at the height of his boxing career. While in training to meet Ted "Kid" Lewis in order to settle a dispute as to who was the welterweight champion of the world, Glover took ill with a cold. Not wanting to forfeit his purse or his claim on the title, Glover went through with his training and the bout with Lewis despite the fact that his illness had progressed to a disturbing level. After he lost to Lewis, Glover was confined to bed for a month, and his condition steadily worsened. Finally, after being rushed to the hospital in Middleboro, Glover succumbed. He was survived by his wife and one-year-old daughter. (Author's collection.)

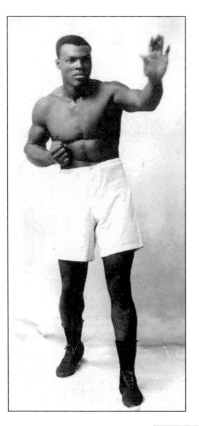

MORRIS HARRIS IN A FIGHTING STANCE, 1910. In the winter of 1910, Sam Langford, hearing that Morris Harris was as tough as they came, brought Morris out from Philadelphia to work as a sparring partner for an upcoming bout. One day during a sparring session, Harris landed a haymaker on his partner's chin, sending him sprawling. The gym was crowded with newspapermen and word got out that Langford had met his match. Soon, Harris was claiming that he could beat Langford. When Sam could stand it no longer, he begged his manager Joe Woodman to get him a real fight with Harris. The two met on December 6, 1910, at the old Mechanics Hall. In the first round, Harris was down six times. In the second round, he was down only once but for over ten minutes. Langford redeemed himself quickly. (Ben Hawes's collection.)

SAM LANGFORD VERSUS HARRY WILLS. Harry Wills, the great black heavyweight of the early 1920s, was Sam Langford's most common opponent. By some reports, they met 22 times over an eight-year period with the six-foot-four-inch tall, 220-pound Wills winning the majority of the bouts. Langford was admittedly past his prime when the rivalry began (he was 31 the first time they fought), but he did manage to knock out Wills twice. (Author's collection.)

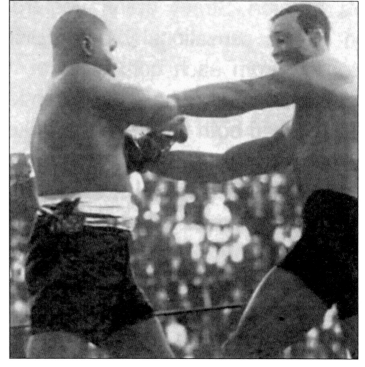

SAM LANGFORD TRAINING FOR "FIREMAN" JIM FLYNN, 1910. Langford did not like "Fireman" Jim Flynn. By mid-1910, the two had fought twice; the first time Flynn was knocked out in the first round, and in the second bout, they went the full distance with no decision. Flynn, a nasty man, always claimed that Langford caught him with a lucky punch in their first bout, and the second bout was more of an indication of what he could do with Langford. Langford always claimed that he carried the Fireman in their second bout so that they would draw a bigger crowd to a rematch. The two foes met for the third time in Vernon, California, on St. Patrick's Day in 1910. After seven interesting rounds, Langford dropped a right hand on Flynn in the eighth that sent him sprawling for good. Langford recalled the end of the bout years later: "In the eighth, I worked Jim around the ring until he was in his own corner. Then I hit him—hot dog yes! The punch drove him through the ropes and into the lap of a newspaperman. About five minutes later they revived Jim and told him what happened. He didn't believe it. He thought the roof had fallen in." (Ben Hawes's collection.)

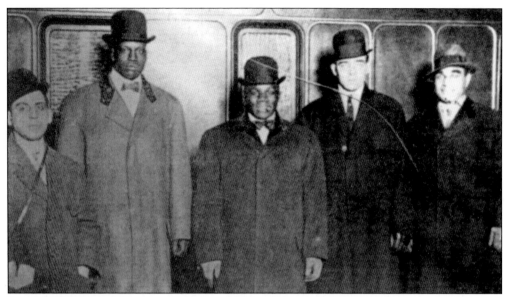

LANGFORD OFF THE TRAIN IN ENGLAND, 1911. Pictured, from left to right, are unidentified, Bob Armstrong, Sam Langford, Dan "Porky" Flynn, and Andrew Jeptha. When Langford returned to England for the second time to meet Iron Hague, he brought with him Bob Armstrong, who had a reputation as one of the finest trainers and sparring partners in the world, and Porky Flynn, a puffed up light heavyweight and Boston native. Armstrong was a capable fighter a decade prior to Langford's rise, but the two men shared an affinity for black cigars and poker. Armstrong also assisted Langford in his preparation for bouts. Flynn, who got the nickname Porky because of his love for pork scraps, was a capable skilled heavyweight and also helped train Langford. Jeptha was a native of South Africa who became the first colored man to win a British title when he defeated Curly Watson for the British Welterweight Title in 1907. (Ben Hawes's collection.)

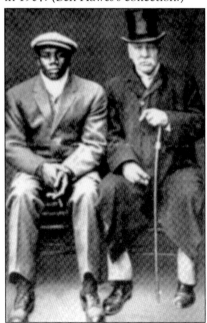

SAM LANGFORD AND JEM MACE, 1911. Sam Langford met the legendary Jem Mace in London prior to his bout with Bill Lang. Mace, the English bareknuckle champion from 1866 through 1871, was one of the more important figures in boxing history. He traveled the world teaching and exhibiting his boxing skill and developed many great fighters. He and Langford had a lengthy chat on the strategy of hitting, but Langford was not overly impressed with Mace's advice. When asked about Jem's wisdom, Langford quipped, "He was a great fighter. But I have my own way of hitting." (Author's collection.)

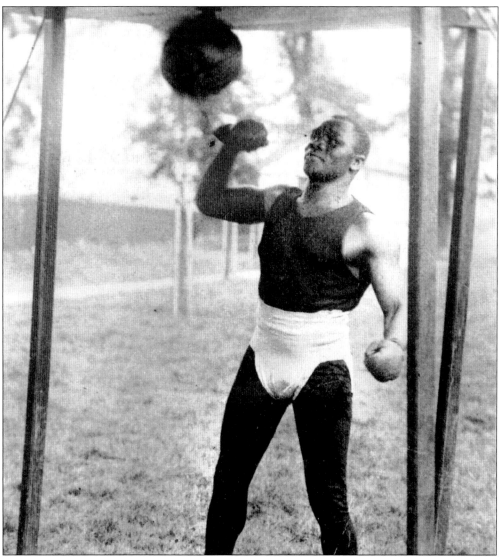

SAM LANGFORD WORKING OUT, 1910. When Sam Langford was in his prime he was nearly unbeatable. In the years between 1904 and 1914, there were not many men who dared to share the ring with him, unless there was some sort of "agreement." Langford always maintained that he never took part in a fixed bout but admitted that there were times when business dictated that he perform under wraps. One glaring example of this was his match with Stanley Ketchel, legendary middleweight champion, in Philadelphia in the spring of 1910. The non-title match was set for 6 rounds and was supposed to be an appetizer for a 25-round title match in California later that year. Langford described his methods: "We had that fight on the coast all wrapped up for later that year. I was to fight Stanley for the championship out on the West Coast, providing of course that nobody got knocked out. Now that Ketchel was not a boy to be fooled with and 'pulling' to him was not easy. He almost broke my neck in the fourth round of that Philly bout. But I had to keep reminding myself of the big match. I needed to keep my cool, cause the only way you were gonna beat Ketchel was to murder him." Both Ketchel and Langford lasted the 6 rounds, but the championship match never materialized. Ketchel was shot and killed later that year. (Ben Hawes's collection.)

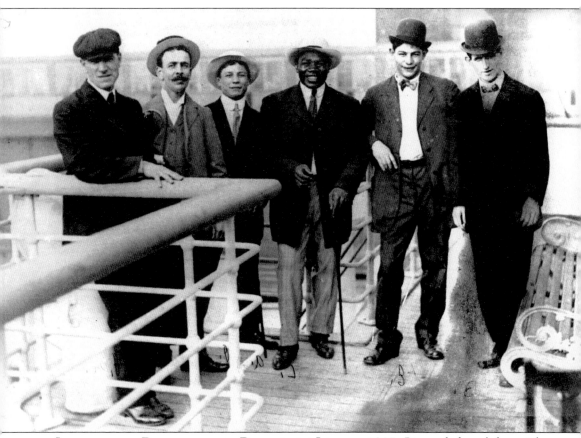

LANGFORD AND DELMONT ON THE DECK OF THE IVERNIA, 1907. Pictured, from left to right, are unidentified, Jim McQuillian, Al Delmont, Sam Langford, unidentified, and Frank Butler. When Langford walked off the Ivernia, England was unaware of his American success. The little news which preceded his arrival had more to do with his courageous loss to Jack Johnson than with his great accomplishments. Frank Butler, a newspaperman, was sent out by promoter Peggy Bettison to greet Langford and his crew and noticed his unusual physical makeup. "I had pictured in my mind a gargantuan Negro, one as big as Jack Johnson himself. And what did I see? A little man. But a second glance told me that he was in fact a colossal man, a sort of mister 5 by 5, for the width of his tremendous shoulders—the largest I have ever seen—could not have been many inches shorter than his total height. His chest was deep and barrel like and his extraordinary arms hung loosely at his sides, his finger tips dropping below his knees. Exaggerating this massive frame was a loud check suit hanging loosely in the American style, which would have been the envy of any bookmaker. Yet holding up this body were the short stocky legs of a lightweight." (Ben Hawes's collection.)

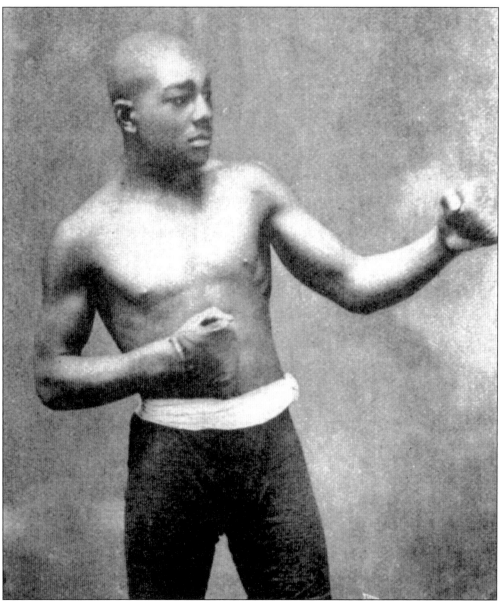

KYLE WHITNEY IN A FIGHTING POSE, 1910. In a matter of five months, Kyle Whitney endeared himself to Boston fans by defeating three former world welterweight champions in Boston area rings. However, not all of Boston embraced the colored fighter. After his January 1910 bout with Honey Mellody of Charlestown, former welterweight champion, Whitney and his manager were attacked by a group of thugs who were upset by the black man's victory. Whitney was quoted the next day as saying, "Boston can be a rough place for a man like me, but I know it is a good place to make a name for myself." And that he did. In March of the same year, Whitney took the famed Dixie Kid to camp in eight rounds at the Armory Athletic Club, and in May, he stopped an ancient Joe Wolcott in nine rounds at Brockton. (Author's collection.)

A Cartoon of Sam Langford and "Gunboat" Smith, 1913. The *Boston Post* celebrates "Gunboat" Smith's victory over Langford in Boston on November 17, 1913. The racist overtones directed at the "home grown" Langford are far from subtle. The cartoon refers to Langford's arrogance and carefree attitude before the bout and the inability of the crowd to see Langford's dark skin through the thick cigar smoke in the arena. (Author's collection.)

Three

THE BOSTON GOB
"We Wuz Robbed!"

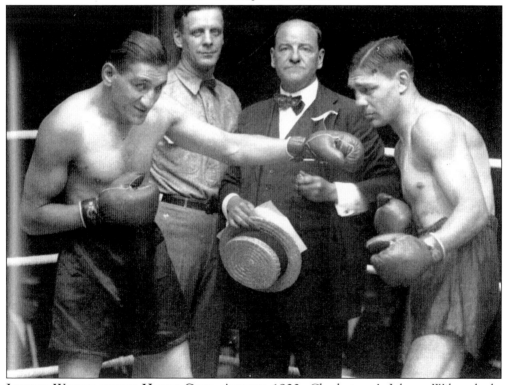

JOHNNY WILSON VERSUS HARRY GREB, AUGUST 1923. Charlestown's Johnny Wilson looks like a character out of an old gangster movie as he squares off with the immortal Harry Greb in New York. Wilson was never a well-regarded champion, but he was popular in Boston. His reign was relatively short, a bit over two years, and he never was a champion who took on just anyone who stepped up. However, Wilson was one of the rich characters who made the Roaring Twenties one of the more memorable decades in boxing history. (Author's collection.)

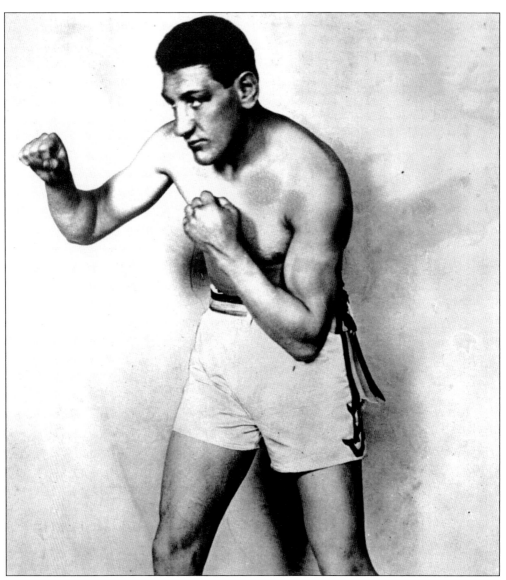

JOHNNY WILSON IN A FIGHTING POSE, 1924. Johnny Wilson, whose real name was Giovanni Francisco Panica, was born in New York, but settled in Charlestown, Massachusetts. His career was marred by rumors of fixes and corruption due to his manager Marty Killea's ties to organized crime. After winning the middleweight title, Wilson, who was a southpaw, came under even greater scrutiny when his managerial reigns shifted from Killea to Frank Marlowe, who was a boyhood friend and known associate of Al Capone's. Throughout the 1920s and into the Depression, Wilson managed the famous Silver Slipper night club in New York, where the patrons ranged from Capone and "Legs" Diamond to Jimmy Durante, George Raft, and Joan Crawford. Wilson was quoted in the *Boston Globe* as saying, "Yeah I knew Al Capone—he had class." After his retirement, Wilson owned and operated a bookstore on Massachusetts Avenue, ran marathon dances in Somerville, owned the Swanee Grill in Roxbury, and later managed the Gilded Cage nightclub on Boylston Street. He died on December 8, 1985, in Boston. (Author's collection.)

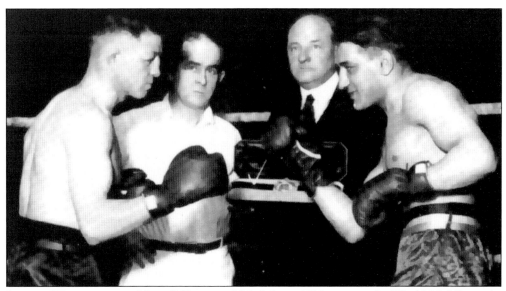

JOHNNY WILSON VERSUS MIKE O'DOWD, 1920. Johnny Wilson won the World Middleweight Championship from Mike O'Dowd at the Mechanics Hall in Boston on May 6, 1920. Wilson won a second match in New York a little over a year later. He never officially defended his title in Boston but only because one of his opponents, George Robinson, came in eight pounds over weight when the two met for the title at the Mechanics Building (previously Mechanics Hall) in 1921. The match was for the world title, but because of Robinson's extra poundage the title was declared not at stake. Regardless, Wilson won the bout in 10 rounds. (Author's collection.)

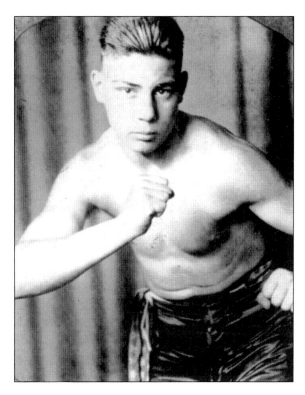

HARRY GREB IN A FIGHTING POSE. One of the finest fighting machines to have ever walked the earth was the "Human Windmill," Harry Greb. A blur of constant movement, Greb had a total of 299 recorded ring contests and held the middleweight title for two years. Greb fought in Boston as early as 1919 up until 1925. In 1926, Greb entered a New York hospital to have some plastic surgery and died coming out of anesthesia. (Author's collection.)

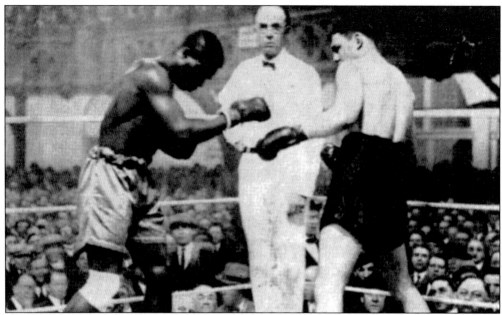

HARRY GREB VERSUS "KID" NORFOLK, 1924. Harry Greb and "Kid" Norfolk met at the Mechanics Building on April 18, 1924. There was no love lost between the men, and the mill was replete with action from the beginning. Greb, who was known to break a rule or two while fighting, was warned several times for foul maneuvers. Norfolk out-fought Greb in the first six rounds. When the bell rang to signal the close of the sixth round, the Kid was in mid-stride with a punch headed for Greb's midriff. The blow landed, and Greb became enraged. He flew at Norfolk, whose back was turned, and landed four blows before the men could be separated. The referee immediately disqualified Greb and declared Norfolk the winner. (Author's collection.)

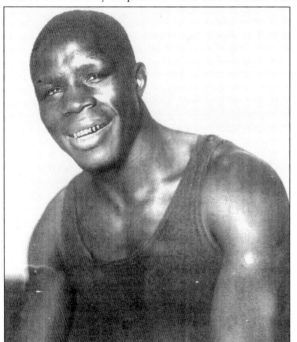

KID NORFOLK, 1922. Kid Norfolk was one of the best light heavyweights of his time. His fought five world champions a total of six times and won each and every match. He first fought in Boston in the winter of 1917 when he met and defeated Billy Miske over the 12-round route. Norfolk claimed the World Light Heavyweight Championship after this bout but received very little recognition. (Bob Carson's collection.)

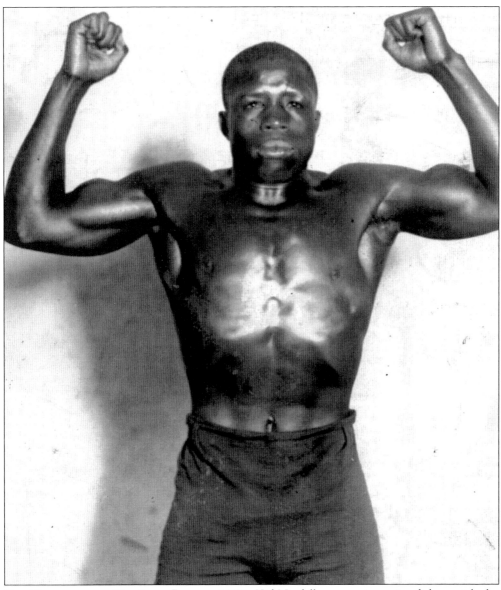

KID NORFOLK WITH HIS ARMS RAISED, 1922. Kid Norfolk was an imposing fighter with the tenacity of a pit bull. His weight generally hovered around 175 pounds, but he often fought heavyweights who scaled well over 200 pounds—and he won. Norfolk liked Boston and frequently found challenges for his Colored Light Heavyweight Championship in the form of local black stars like George Robinson, Lee Anderson, Jim McCreary, and Clay Turner (the latter being of Native American decent but often portrayed in the press as a black man). The Kid lost only twice in Boston, once to Turner and once to McCreary, but avenged both defeats in return matches. He, like Sam Langford, learned a great deal from George Byers and visited his home whenever he was in town. McCreary, who fought Norfolk on three occasions, described his abilities as such: "He wasn't there when I went to hit him, but he was standing right in front of me—weaving and the like. Then 'wham' he'd hit with that hammer and I would be seeing spots for the next two rounds. I don't really remember how it ended." (Author's collection.)

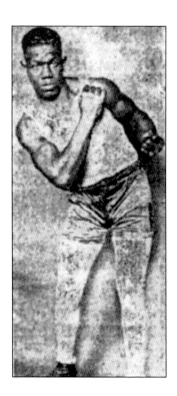

JIM MCCREARY, THE "BATTLING PREACHER," 1921.
Jim McCreary, also known as the "Battling Preacher," was a popular performer in Boston, c. 1920. The evangelic moniker was given to him by Lawrence Sweeney of the *Boston Globe* who often noticed "the large following of Boston's colored church goers who (turned) out by the hundreds for each of McCreary's bouts." (Author's collection.)

LEE ANDERSON IN A FIGHTING POSE, 1922.
Lee Anderson came to Boston in the fall of 1922 to fight Kid Norfolk at the Mechanics Building. Norfolk won the rugged 12-round contest and turned the trick again when he and Anderson met at the same venue three months later. Lee stayed in the New England area fighting in Boston as well as making frequent trips to Maine and Buffalo, New York. Anderson, who counted Sam Langford and "Battling" Siki among the men he defeated, fought the last recorded bout of his career at Fenway Park in 1928 when he was knocked out by "Big Bill" Hartwell in 8 rounds. (Author's collection.)

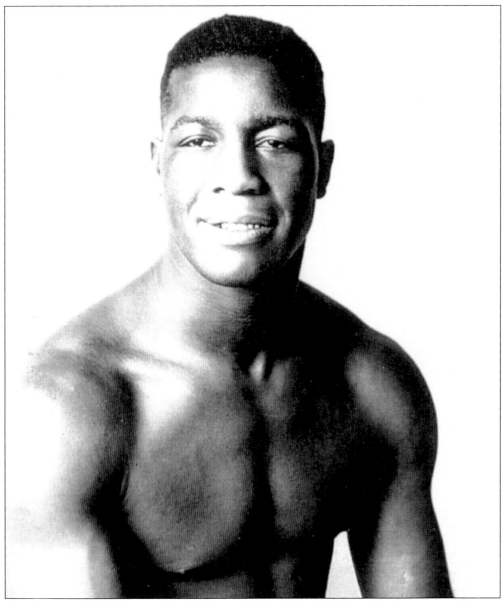

BOB LAWSON, 1926. Managed by the famous Walk Miller, Bob Lawson, who was a stablemate of Theodore Flowers (known as "Tiger Flowers"), fought in Boston several times. Lawson, who was known as the "Alabama Bearcat," did not fight as frequently in Bean Town as the more famous Flowers did, but he did score some impressive wins. His best win in Boston was a 10-round decision over Tom Kirby, the former national amateur heavyweight champion. (Author's collection.)

Johnny Noyes and William "Battling" Thomas, 1920. William "Battling" Thomas and Johnny Noyes were never headliners, but they waged a 10-match, neighborhood war that many would have paid good money to see. They both hailed from Boston's South End, and each claimed what the press referred to as the "Colored Championship of Lenox Ave." Their 10 official bouts in the ring hardly settled the matter of who was indeed superior because the series was only slightly tipped in Thomas's favor, six to four. However, each man developed a deep hatred for the other. Their feud reached an apex when the two boxers became engaged in a heated argument outside of a restaurant on Tremont Street. Blows were exchanged, and the men spilled out into the street. Noyes, who was reportedly getting the worst of the argument, pulled a knife from his coat and threatened to cut Thomas. Police arrived before Noyes could take action, and both men were arrested. Evidently, they somehow resolved their differences and neither was charged with any crime. The two men fought a charity exhibition match two months later without incident. (Author's collection.)

"SUNNY" JIM WILLIAMS, 1925. "Sunny" Jim Williams was also managed by Walk Miller. When he came to Boston with Tiger Flowers in the summer of 1925 to fight Bing Conley of Maine, he was fairly unknown. Williams and the Flowers worked out daily at George Byer's gymnasium, and the press soon learned the Williams was not a man to be taken lightly. Lawrence Sweeney of the *Boston Globe* reported, "From what we have seen Williams is a marvel as a fighter. Conley had better be careful or he may find himself on the short end. This Sunny Jim pushed (Lee) Anderson around the ring with ease and punched Lee with little effort. He also had the better of a short session with the Deacon (Flowers) in which he displayed a remarkable ability to counter blows while in motion." At Braves' Field two nights later, Williams made short work of Billy Conley (who substituted for the injured Bing), battering him, and knocking him out in the fifth round. The next year, Williams made a two-year trip to Australia where he won, lost, and regained the World Middleweight Championship of the British Empire. It was the only title for which he ever fought. (Author's collection.)

"JOCK" MALONE. "Jock" Malone fought in Boston more than a dozen times and scored some of his most impressive victories there. In 1922, he defeated Mickey Walker in 10 rounds and, over the course of the next two years, took on such hardened veterans as Panama Joe Gans, Augie Ratner, and Roland Todd. By 1924, Malone's trips to Massachusetts became far less fruitful. That year he suffered the loss of two important bouts, a 10-round decision to Frank Moody and a brutal knockout by Johnny Wilson. Prior to the bout with Wilson, Malone guaranteed a victory and stated that if he lost he would jump off the Charlestown bridge. True to his word, Malone, after being knocked stiff in the 6th round of his contest with Wilson, jumped from the bridge fully clothed into the mouth of Boston Harbor. (Author's collection.)

"PANAMA" JOE GANS, 1923. Joe Gans, whose actual name was Cyril Quinton, moved out of New York to live and fight in Boston during 1918. His opponents, with the exception of Gloucester's tough Joe Rivers, were all local black fighters. The best of the lot was George Robinson, who campaigned for several years out of Boston and held victories over Johnny Wilson and some other top men. Gans had mixed results in Boston and, after heading back to New York in early 1919, did not return until 1921 when he fought Jock Malone. Gans was a top welterweight contender in the early 1920s, and he returned to Lowell in 1927 to fight Homer Robertson but never fought in Boston again. (Author's collection.)

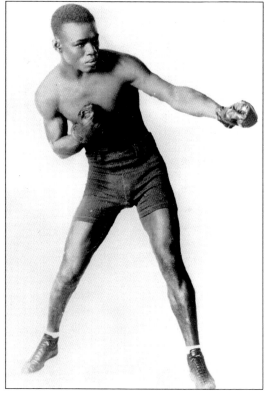

JOE MCGALE, THE "FRISCO KID," 1925. A speedy welterweight who possessed a fair amount of power, Joe McGale, also known as the "Frisco Kid," first showed in Boston in the spring of 1925. He fought two sensational bouts with Sailor Darden at the Mechanics Hall in which he was described by the local press as "possessing an inordinate amount of speed and science." His dominance of Darden was complete. The Frisco Kid, who actually hailed from the West Indies, fought the heavy hitting future welterweight champion Tommy Freeman two months later at Braves' Field. Although he won the middle rounds, he could not cope with the heavier Freeman's pressure and lost an eight-round verdict. (Author's collection.)

DICK "HONEYBOY" FINNEGAN, 1926. Dick "Honeyboy" Finnegan began his career in the U.S. Navy in 1920 and won the championship of the Atlantic Fleet before going on to win the U.S. Navy championship. His professional career was highly successful and Honeyboy was on the verge of a championship match on several occasions. His most notable moment may have been when he won a 10-round bout against Andre Routis, world featherweight champion, on opening night of the brand new Boston Garden. (Author's collection.)

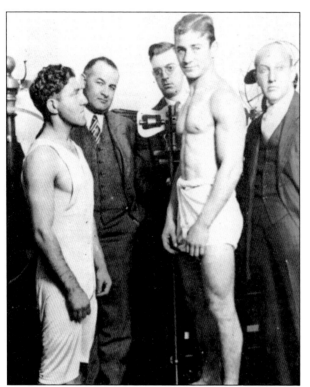

"Red" Chapman Watches Benny Bass Weigh in, 1927. "Red" Chapman (left), who was managed by Charlie Cardio, met Benny Bass (right) in Philadelphia for the featherweight title on September 12, 1927. Chapman and Bass had met earlier in the year in New York, and Bass won on a foul in the first round. Chapman was a very tough performer, but Bass had a bit too much for him in their rematch and was declared the winner. (Author's collection.)

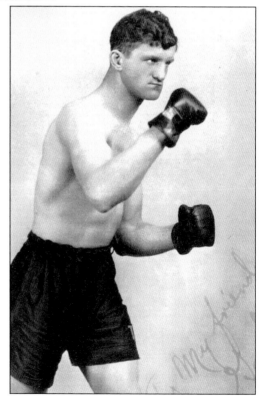

Johnny Sheppard, 1925. A tough bantamweight, Johnny Sheppard had bad luck when it came to fighting for championships. When Abe Goldstein, the American flyweight champion, came to Boston in 1922, Sheppard gave him a 10-round boxing lesson. However, because Sheppard was a few pounds over the weight limit, the title was not at stake. Almost two years later, Goldstein returned to Boston, this time with the World Bantamweight Championship fastened around his waist. Sheppard defeated Goldstein again, but the match was not for the title. Goldstein lost his title that same year, and Sheppard never got another title shot. (Tracy Callis's collection.)

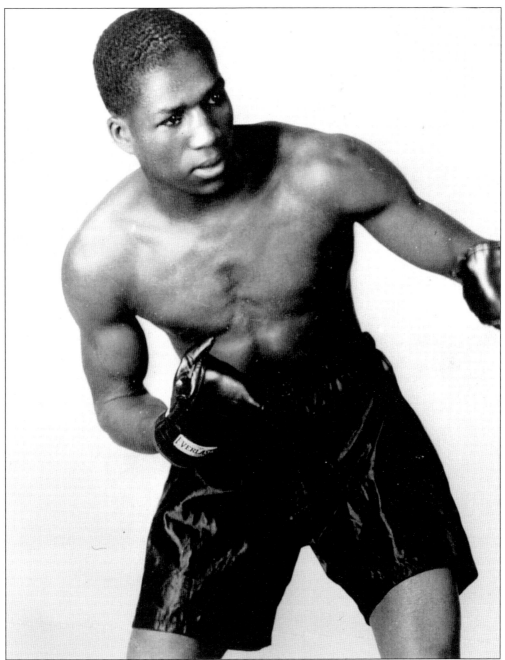

WILLIAM "GORILLA" JONES, 1929. William "Gorilla" Jones was a frequent visitor to Boston and made several spectacular appearances in the ring. He virtually ended the career of Al Mello when he knocked him out in six rounds at the Boston Arena in 1929. Jones, who went on to capture the middleweight title in 1931, fought until 1940 when he retired and moved to Los Angeles. He developed a relationship with actress Mae West until the actress's death in the 1980s. (Author's collection.)

"GENTLEMAN" JACK MCVEY, 1925. "Gentleman" Jack McVey, whose real name was Julius Williams, first came to Boston as a substitute fighter in 1929. Arthur Flynn, a durable light heavyweight from Lawrence, was scheduled to face Homer Robertson, but Robertson had taken ill. The promoters of the show sent for McVey and, three hours later, he deboarded a train at South Station. McVey was not in the best of shape but still managed to cut Flynn to pieces. In the ninth round, the bout was stopped, and the referee rescued Flynn. (Author's collection.)

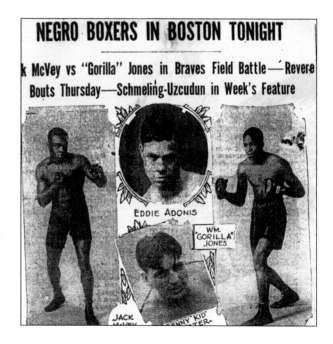

A JACK MCVEY AND "GORILLA" JONES HANDBILL, 1929. Jack McVey and "Gorilla" Jones fought for the colored middleweight title at Braves Field on June 25, 1929. The entire card was delayed more than two hours because the second game of the Boston Braves doubleheader went into extra innings. There were to have been three preliminary bouts prior to the Jones-McVey match, however, after the skies began to open up after the first bout, the promoters of the show immediately sent in Jones and McVey. They fought in the open air of the ballpark, without a canopy protecting the ring, and sloshed through the rain for 10 rounds. (Author's collection.)

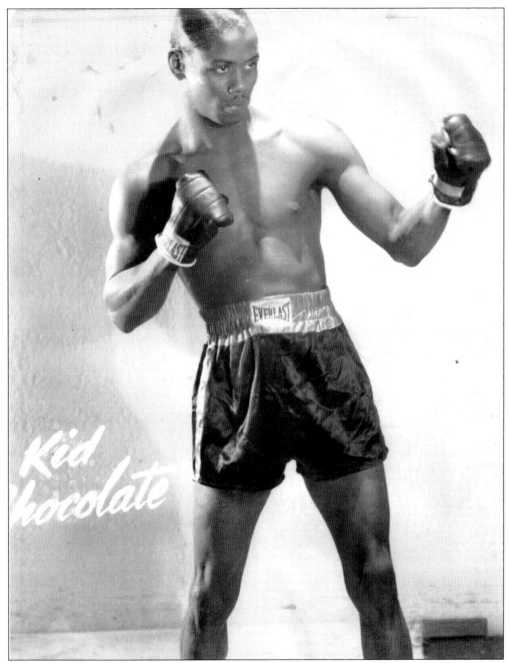

"Kid Chocolate" in a Fighting Pose, 1928. Eligio Sardinas-Montalbo, better known as "Kid Chocolate," came to Boston in 1929 and electrified a large Boston Garden crowd by destroying Johnny Vacca in 10 rounds. The *Boston Globe* gushed, "Never before have we seen this kind of speed and showmanship. Chocolate never gave Johnny a chance to set. He was in and out, like a tornado—tearing everything in its path. This Cuban is indeed a coming champion and we hope for the opportunity to see him again." The Boston fans saw Kid Chocolate again but had to wait. He did not fight in Bean Town again for another three years. (Author's collection.)

A BOSTON GARDEN ADVERTISEMENT, 1929. The Boston Garden opened on November 17, 1928. Built by the legendary Tex Rickard for the purpose of promoting boxing matches, the Garden was originally named after Madison Square Garden in New York. The first fight card held at the Garden on opening night featured Honeyboy Finnegan's 10-round victory over Andre Routis. (Author's collection.)

"TEX" RICKARD, 1926. The Don King of his day, "Tex" Rickard was the most influential matchmaker of his time. He promoted such legendary bouts as Jack Johnson versus Jim Jeffires, Joe Gans versus "Battling" Nelson, and Jack Dempsey versus George Carpentier. His guile and promotional flare helped him turn boxing into a multi-million dollar business and himself into a powerful player in the pugilistic world. For years, he held an office at Madison Square Garden in New York, which at that time was the mecca of boxing, and he was responsible for the building of the beloved Boston Garden. (Author's collection.)

"ONE PUNCH" AL WALKER, 1927. "One Punch" Al Walker was not an exceptional fighter. Tall, gangly, and light for his height, he was often easily overpowered by larger and sturdier heavyweights. Walker held the distinction of being the first black fighter ever to perform at the Boston Garden when on November 30, 1928, he was knocked out in the fifth round of his match with Jimmy Bryne. (Author's collection.)

HARRY SMITH, 1930. There was no getting around the fact that Harry Smith was a hard puncher. In 1930, Al Lippe, one of the more famous managers of his time, stated, "He is the most ferocious puncher I have ever seen and in my opinion can beat any middle or lightheavy in the world." Smith demonstrated his power to Boston fans when he knocked out in succession Gary Leach (in the first round), Homer Robertson (in the seventh round) and Billy Green (in the third round). Harry never got the opportunity to fight for a title and died of a cerebral hemorrhage at Chicago en route to California. He was to be married two days later. (Author's collection.)

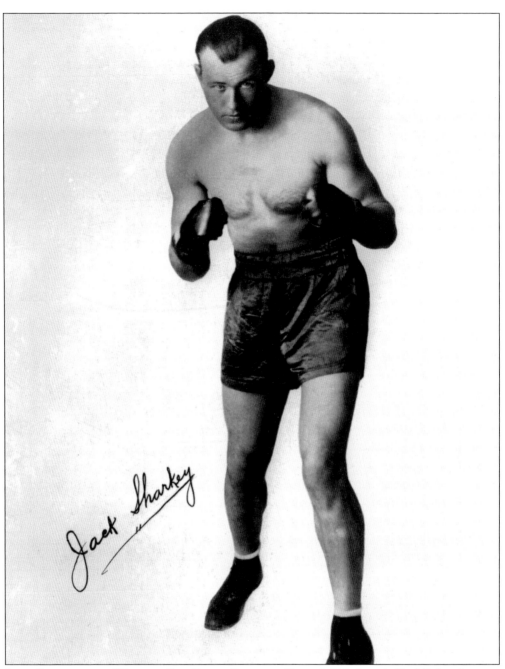

JACK SHARKEY, THE "BOSTON GOB," IN A FIGHTING POSE, 1931. Joseph Paul Zukauskas was born in Binghamton, New York, in 1902. He ran away from home as a teenager and joined the U.S. Navy. Zukauskas served two, two-year stints with the U.S. Navy, his home port being Boston. After serving out his term, Zukauskas wandered into a fight club and asked for a match. The fight club manager asked him his name and after Zukauskas answered, the manager stated, "Go get yourself a name and then come back." Taking the "Jack" from Jack Dempsey and the "Sharkey" from a famous prizefighter and navy man, Tom Sharkey, Joseph returned to the club as "Jack Sharkey," and won his first fight. (Author's collection.)

JOHNNY BUCKLEY AND JACK SHARKEY, 1931. Pictured in this photograph, from left to right, the two men in the center are Johnny Buckley and Jack Sharkey. The other men are unidentified. Buckley managed the career of the erratic and irascible Jack Sharkey. He often complained that Sharkey could have been a better fighter if he had kept his head more often. "The boy let's his emotions dictate how he fights. If he has a bad day on the day of a fight, he is likely to tear the place down. The fans like it sometimes, but it is bad for Jack. He can beat any heavyweight alive when his head is right." (Author's collection.)

JACK SHARKEY POSES DURING A WORKOUT, 1932. Jack Sharkey gained the reputation as an up and down performer early on in his career. He was not well liked by the press because his personality was not the kind that sold newspapers. His ill-tempered ways were not well received by fans and other boxing men. "I was a hot headed guy," Sharkey said. "You could never tell what I would do. If I got a bad decision I would go into a tantrum and it might look like I was crying," Sharkey told Peter Heller in the mid-1970s. "But it didn't bother me as long as I got that old paycheck." (Author's collection.)

JIMMY MALONEY IN A FIGHTING POSE, 1931. One of Jack Sharkey's early rivals was South Boston's Jimmy Maloney. Loved by Boston's Irish, Maloney was a viable contender for most of the mid- to late-1920s. His career started with a flourish in 1924 and ended in a sea of disappointment in 1932. Much of Boston thought that they had a rising champion in young Maloney when he started out, but after a few setbacks, including a knockout loss to Leo Gates of North Adams, much of their enthusiasm was curbed. In 1926, Maloney reasserted himself by going undefeated and beating viable opposition like George Cook, Charlie Weinhert, and Arthur Dekuh. South Boston was full of hope again when 1928 began and even overlooked a knockout loss to Jack Sharkey at mid-year in the hope that they could boost their man towards a title shot. Any and all optimism was lost again when Maloney was crushed in one round by George Godfrey in Philadelphia and then again in his next start by Tom Heeney. (Author's collection.)

A JIMMY MALONEY ADVERTISEMENT, 1927. Maloney fought professionally from 1924 until 1932. The majority of his bouts took place in Boston and he was quite successful. Perhaps his best year was 1928 when he took the measure of fellow contenders Jack Renault, Jack DeMave, and Johnny Risko, the "Rubber Man." In 1930, Maloney also beat future heavyweight king Primo Carnera, the giant Italian's first loss in the United States. (Author's collection.)

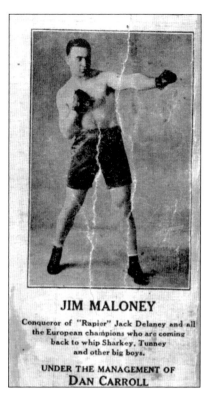

JIMMY MALONEY, DAN CARROLL, AND DICK FINNEGAN, 1927. Carroll was one of the big players in Boston. He controlled a stable of fighters from his Court Street offices that included such men as Maloney, Finnegan, Arthur Flynn, Red Chapman, Tom Kirby, and George Manolian. "Big Dan's" reputation as a manager allowed him leverage that few in Boston could match. He demanded the best match-ups and money for his men and often controlled matchmakers with his well-maintained stable of fighters. (Tracy Callis's Collection.)

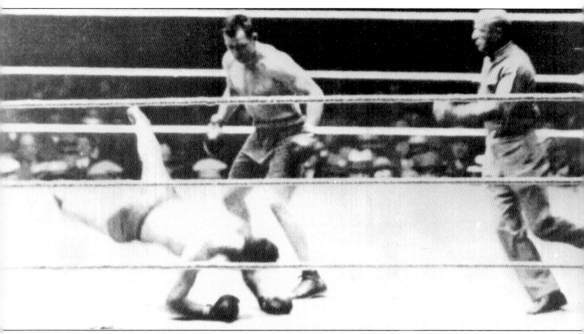

JACK SHARKEY VERSUS JIMMY MALONEY, 1927. When both Jimmy Maloney and Jack Sharkey were first-year professionals, they met at Mechanics Hall, and Maloney won a decision in 10 rounds. Sharkey took his revenge a year later when he copped his own 10-round verdict. The two met a total of four times, and Sharkey won three out of the four, cementing his dominance by knocking out Maloney in their final match. Sharkey always maintained that he liked Maloney, and that the Boston papers had built up their feud. (Author's collection.)

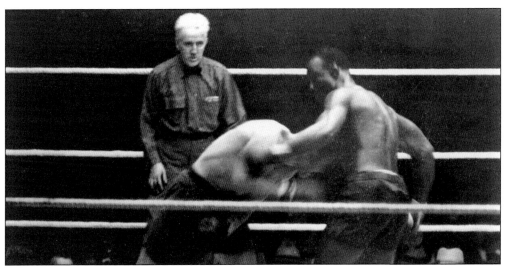

JACK SHARKEY VERSUS HARRY WILLS, 1926. Perhaps one of the more important victories for Jack Sharkey was his October 1926 conquest of long-time black-contender Harry Wills. For most of Jack Dempsey's reign, from 1919 to 1926, Wills, also known as the "Black Panther," was considered his number one challenger. Wills never got his crack at Dempsey simply because he was black. Sharkey knew an opportunity when he saw it and thought a win over the aging Panther, who had been active since 1911, would put him in line for a title shot. Sharkey dominated the bout, and Wills fouled out in the 13th round. (Author's collection.)

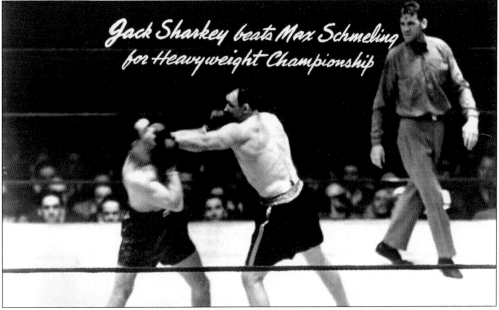

JACK SHARKEY VERSUS MAX SCHMELING, 1932. In their second battle for the title, (Max had claimed a foul in the fourth round of 1930 title match and been awarded the bout and the title), Schmeling and Sharkey both fought a tactical, boring, and close fight. In a match that was characterized by jabbing, clutching and clinches, Sharkey won the decision and was crowned World Heavyweight Champion. Joe Jacobs, Schmeling's manager, upon hearing the decision, let out his now famous line: "We wuz robbed!". (Author's collection.)

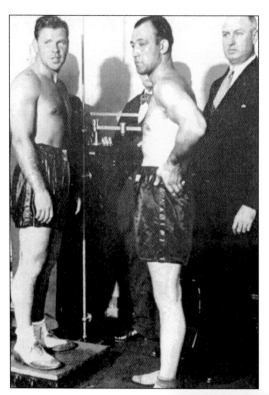

JACK SHARKEY AND MICKEY WALKER, 1931. In a performance that characterized all that made Jack Sharkey such an enigmatic performer, the Boston Gob waltzed through 15 rounds with former middleweight and welterweight champion Mickey Walker. The "Toy Bulldog," as Walker was known, was little more than a blown-up light heavyweight when he entered the ring to face Sharkey. Mickey was aggressive, energetic, and bent on winning. Sharkey, in contrast, was methodical, slow, and seemingly uninterested. At the end of 15 rounds, the bout was declared a draw. Most ringsiders felt that Sharkey was lucky to escape a loss, but he never escaped the stigma that was attached to being held to a draw by a much smaller man. (Author's collection.)

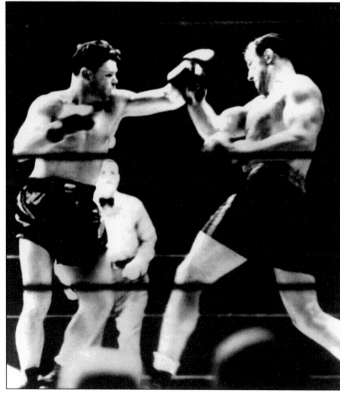

ERNIE SCHAFF IN A FIGHTING POSE, 1930. Schaff was a native of New Jersey but was based out of Boston for his entire professional career. A legitimate contender for close to five years, he fought from 1925 until 1933. Schaff finished the career of Jimmy Maloney in 1931 by knocking out the South Boston man twice, once in 1 round and once in 2 rounds. In 1932, Schaff took a terrible beating from future heavyweight champion Max Baer in a 10-round bout in Chicago. Four bouts later, he was knocked out by Primo Carnera in the 13th round of a bout in New York. Schaff died a few days later from what was termed, simply, brain injuries. (Author's collection.)

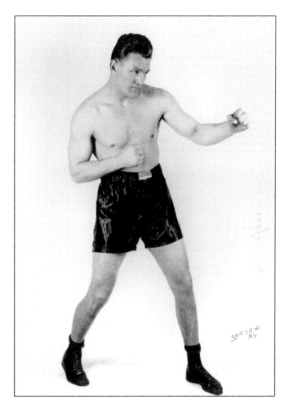

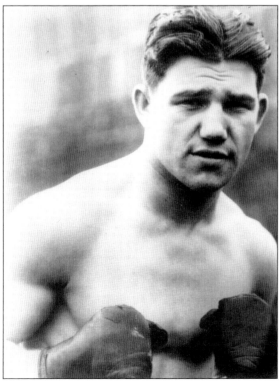

LOU BROUILLARD IN A FIGHTING POSE, 1935. Lou Brouillard was a transplanted Canadian who fought out of Worcester and Boston for most of his career. Managed by Johnny Buckley, Brouillard won the World Welterweight Championship from "Young" Jack Thompson in Boston in 1931. He lost his title to Jackie Fields the next year but won the middleweight championship from Ben Jeby in New York in 1933. Brouillard lost the title less than two months later and had to wait four years for his next opportunity. In 1937, he lost on a foul in the sixth round to Marcel Thil in another middleweight title match and never contended for a championship thereafter. (Author's collection.)

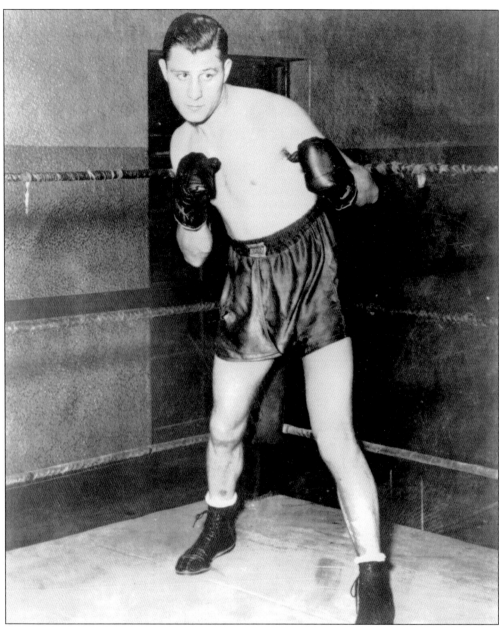

TONY SHUCCO IN A FIGHTING POSE, 1933. Born in the North End in 1911, Anthony Sciucco (he changed his name when he became a fighter), won great accolades as an amateur, capturing the amateur lightweight championship in New England and both the National and International Golden Gloves Championships in 1928. Sciucco quickly gained weight after turning professional the same year and, by 1929, was trading punches with the likes of Homer Robertson and Johnny Indrisano. Tony's career was successful, but he never put together a winning streak that ensured him a title match. He had some very high-quality wins over men such as Bob Olin, Maxie Rosenbloom, Lou Brouillard, Jim Braddock, Al Gainer, and Jack Sharkey. (Author's collection.)

A CARTOON FROM THE BOSTON GLOBE, 1922. The Amateur Athletic Union national boxing tournament was held in Boston every year in April from 1904 through 1934. This cartoon of the National Amateur Tournament depicts the good, the bad, and the ugly from the preliminary round matches in 1922. (Author's collection.)

JOHNNY INDRISANO IN A FIGHTING POSE, 1929. A welterweight contender of the mid-1920s, Johnny Indrisano beat five world champions in non-title bouts but never fought for a world championship. Born in East Boston, Indrisano fought as a professional for 10 years, beginning in 1924. When his fighting days were over, he went to work in Hollywood where he became a fight scene consultant for some of the biggest producers in the motion picture business. Among the actors with whom Indrisano worked were Cary Grant, John Garfield, Spencer Tracy, Mickey Rooney, Jimmy Durante, and Ronald Reagan. (Author's collection.)

BRUCE FLOWERS AND JOE WOLCOTT, 1928. "Barbados" Joe Wolcott gives the young Flowers some pointers prior to the his bout with Boston's Dick Honeyboy Finnegan at the Boston Arena. Finnegan came into the bout riding a two-and-a-half-year winning streak and holding the featherweight championship of New England. Wolcott's advice must have been useful because Flowers dominated the 10-round bout and won the decision. (Dave Bergin's collection.)

JACK SHARKEY ON THE CANVAS, 1932. Jack Sharkey lost his heavyweight title to the giant Italian Primo Carnera in 1933. Carnera's rise to fistic prominence was guided by the mob and many questioned the legitimacy of his title-winning knockout of Sharkey. If Sharkey did take a dive he denied it until his dying day. "He hit me harder than I had ever been hit," said the ex-champion. (Dave Bergin's collection.)

JACK DEMPSEY WITH HIS MANAGER, 1922. One of the most intriguing and famous champions of any era was Jack Dempsey. He, much like John L. Sullivan, made his reputation as a puncher, and his ability to knock men out made him a very rich champion. Managed by the very able Jack "Doc" Kearns, a former fighter himself, Dempsey only made one trip to Boston during his title reign. In the fall of 1922, Dempsey appeared at the Mechanic's Building in a three-round exhibition with heavyweight Jack Thompson. Dempsey was notorious for never taking it easy in the ring. His sparring partners were expected to take punishment and attempt to give it back. The Boston press attempted to draw up more interest in the exhibition between the two by running feature articles on Thompson. The members of the Faneuil Athletic Club, who were promoting the show, brought Thompson in a week before the match to help build the gate. They had newspapermen watch his workouts with George Robinson, who fed into the hype. The press followed suit by building Thompson up as a man out to show the world that he was the champion's equal. Thomspon had few such aspirations and, when Dempsey finally came to town the night of the exhibition, the two boxed a fast but harmless three-round exhibition. The Boston fans were duped. (Author's collection.)

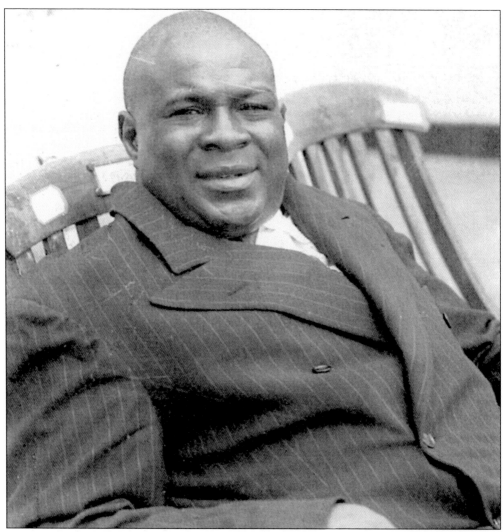

GEORGE GODFREY. The career of George Godfrey, the "Shadow of Leiperville," was anything but ordinary. Born Feab Smith Williams, the six-foot-three-inch tall, 240-pound heavyweight took his fighting name from the famous "Old Chocolate" of Boston. Godfrey's early career, which began in 1919, was anything but stellar, but by the end of 1925, he was a force to be reckoned with. Against black opponents, he was nearly unbeatable, scoring a number of impressive victories. It was against the white heavyweights that Godfrey seemed to turn into a turtle, and several times he was accused of throwing matches against white opponents. In 1926, Godfrey came to Boston to take on fellow contender Jack Sharkey. In what was described as one of the worst bouts ever seen in Boston, the fight did little to improve Godfrey's image. The *Boston Globe* reported, "Godfrey did little fighting, choosing instead to hold onto Jack and paw at him harmlessly." Sharkey won the contest, and Godfrey left Boston under more suspicion that he had not fought his best. He returned in the fall of 1929 to face Jimmy Bryne, a man he had knocked out a few months before in Philadelphia, and again his performance was questionable. In a bout stopped in the seventh round, Godfrey was again openly accused of holding back. The *Boston Globe* reported, "Godfrey has shown twice here and let us hope it is the last time. He does not seem interested in the fight game any longer. He pulled Jimmy (Bryne) around the ring like he was his sweetheart." (Author's collection.)

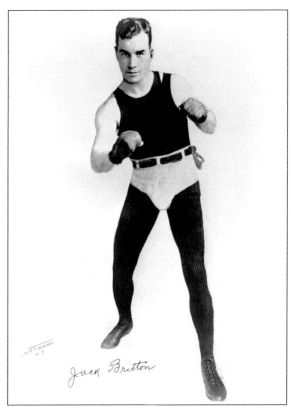

JACK BRITTON IN A FIGHTING POSE, 1922. Jack Britton was one of the great welterweight champions of all time. He fought in Boston a total of 15 times from 1912 through 1929. Britton won his title in Boston in 1915 when he took the measure of Mike Glover of Lawrence and then lost the championship to Ted "Kid" Lewis two months later at Mechanics Hall. After winning his title back in 1916, he made four successful defenses in Bean Town that year. (Author's collection.)

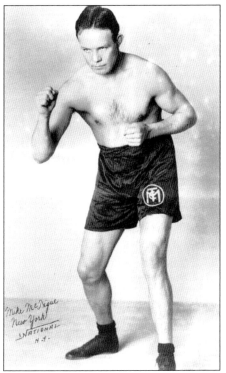

MIKE MCTIGUE, 1923. Mike McTigue was another champion who frequented Boston prior to and after winning a world title. McTigue, who was born in Ireland, once said of Boston, "The Irish here make me feel like I am back home in the old country. It is an advantage for me to have such backing. The other guy must feel all alone." McTigue was a true professional who learned his craft against some of the best men of his era. He won his light heavyweight title on St. Patrick's Day in 1923 in Dublin against Battling Siki. (Author's collection.)

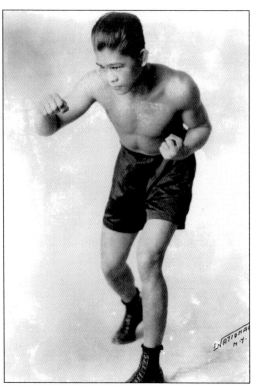

PANCHO VILLA IN A FIGHTING POSE, 1921. Pancho Villa, a flyweight born in the Philippines in 1901, came to the United States in 1922 where he immediately made a huge splash with American fans. His performances in Boston were well received when he defeated the likes of "Young Montreal," Abe Friedman, Willie Woods, and Tony Thomas. Villa held his flyweight title from 1923 until 1925 when he died after a bout with Jimmy McLarnin. The cause of his death was listed as blood poisoning caused by an infected tooth. (Author's collection.)

"LITTLE" DANNY EDWARDS, 1920. "Little" Danny Edwards was another flyweight of championship caliber. A native of the West Coast, Edwards came to Boston in 1922 where he defeated, among others, the tough Chick Suggs and contender Young Montreal. Later in the year, Edwards fought a desperate battle with Pancho Villa in Roxbury for the American flyweight title. The bout was close, and many thought Little Danny deserved a draw, but Villa won the decision and retained his title. Although Edwards remained a contender for many years, his bout with Villa was the only title match he ever had. (Author's collection.)

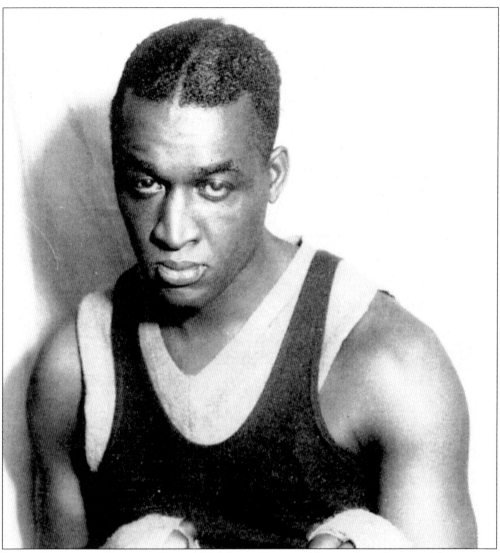

LARRY GAINES IN A FIGHTING POSE, 1926. Larry Gaines, a Toronto born heavyweight, came to Boston in the summer of 1928 and took the measure of Tom Kirby (a former national amateur champion who had recently returned from the Olympics) and Jack Gagnon. Larry took the bouts because he wanted to force Jack Sharkey or Jimmy Maloney to fight him. Both had repeatedly refused offers to come to Toronto to face off with Gaines, so he tried to meet them in Boston. Eddie Mack, the Boston Garden matchmaker, surprised Gaines with an invitation to his office. Gaines told of his conversation with Mack in his autobiography; "Mack offered me a match with Maloney. 'It could be a good match,' he told me, 'and maybe after that I could get you Sharkey. You could make a lot of dough from a couple of bouts like that.' Then he paused and rubbed his chin. 'Mind you Larry, you'll have to go in the tank'…meaning I would have to loose. I told him I couldn't swim. Mack brightened up and said, 'I told them you would say that. I was afraid you would agree to take a dive and then go out there and flatten Maloney. There are some hard men behind this thing Larry. If you had crossed them up there wouldn't have been many more summers for you and I.'" (Author's collection.)

"Chick" Suggs, 1925. "Chick" Suggs, a native of New Bedford, was a long time contender for both bantamweight and featherweight honors and was called the "Uncrowned King of the Bantamweights" during his prime. Despite beating almost every top-flight fighter in his division, Suggs never earned a title chance. He was so well respected and his record so sterling that, in 1925, Tex Rickard rated him above champion Charley Phil Rosenburg in his yearly rankings of fighters. Suggs fought from 1917 until 1929, during which time he competed in over 150 contests. In 1925, Suggs won 42 consecutive fights. (Author's collection.)

Joe Wolcott, 1934. After his fighting days, Joe Wolcott (who like many ex-boxers did not save any money from his fighting days) lived on the salary of any odd job that he could find. In his later years, he worked as a porter at Yankee Stadium and frequently took interviews for little money. His end was very sad, and for many years prior to his death, he was believed to have been deceased by even his family. (Author's collection.)

SAL BARTOLO, JOHNNY INDRIASANO, TONY DEMARCO, AND JOHNNY WILSON. A group of Boston's best fighters gather at a charity event, c. 1950. Pictured, from left to right, are Sal Bartolo, Johnny Indriasano, Tony Demarco, and Johnny Wilson. (Author's collection.)

HOMER ROBERTSON, 1926. Homer Robertson was a native of Pittsburgh who came to Boston for the first time in 1921, as an amateur, to compete at the National Championships. After placing second in both the middleweight and light heavyweight class in that tournament, Robertson returned to Boston in 1922 where he swept the middleweight division and was crowned the national champion. Robertson turned professional and, after a brief trip to Cuba, settled in Boston where he fought for another 10 years. For several years during the mid-1920s, Robertson was one of the better middleweights in the business. (Author's collection.)

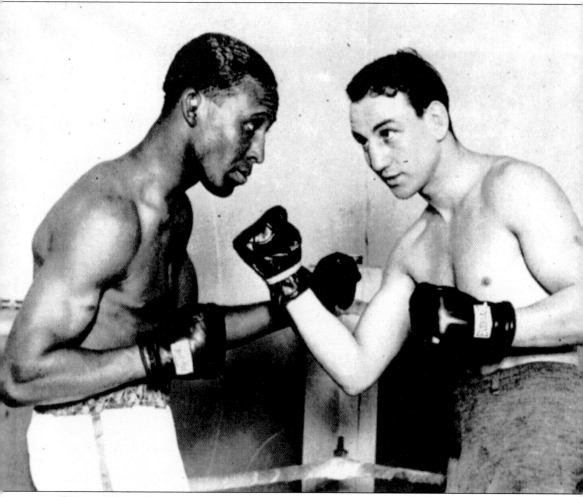

"Young" Jack Thompson, 1931. World champion "Young" Jack Thompson (left) was not very successful in Bean Town. He came for the first time to the city in the summer of 1931 to fight Lou Brouillard (not shown here) and lost in 10 rounds. The rematch three months later, which sold out the Boston Garden, was a title bout in which Brouillard defeated Thompson and won the welterweight championship. (Author's collection.)

"Tiger" Jack Fox, 1935. Perhaps one of the greatest punchers of all time, "Tiger" Jack Fox made only three trips to Boston during his long impressive career. His first bout, against Lou Brouillard, was undoubtedly his most impressive. Using a potent right hand, Fox battered the veteran Brouillard into submission in seven rounds. It was the one and only knockout Brouillard suffered during his entire career of over 100 bouts. Still, the Boston press was not impressed. In an interview after the bout, the *Boston Globe* referred to him as a quiet man. "When I asked him how long he had been fighting," the reporter stated, "Fox replied by holding up eight fingers. He may be the great fighter his record suggests, but as far as an interview, the Tiger might just as well be a Pyramid." (Author's collection.)

ROY MITCHELL, 1929. From Nova Scotia, Roy Mitchell, also known as the "Bronze Apollo," was a huge puncher with great skill and courage. He came to Boston like many before him to further his pugilistic career. Mitchell won his first three bouts in Boston and impressed the fans and press with his displays of punching power, but it was mostly downhill from there. Mitchell typically weighed 175 pounds, but after demolishing his early opposition so easily, promoters could no longer find any light heavyweight opponents for him. He was therefore matched with much larger men and began to loose far more frequently. (Author's collection.)

Four

THE ROCK AND THE BROWN BOMBER
"They Can Run, but They Can't Hide."

ROCKY MARCIANO WITH PRESIDENT EISENHOWER. Perhaps the most well known and well loved of all Boston's champions was Rocky Marciano, shown here with President Eisenhower. Marciano was born in Brockton, Massachusetts, on September 1, 1923. After a brief amateur career in which he posted a mildly impressive record, Marciano turned professional in 1948. A short, modestly built heavyweight, Marciano was proof that heart, determination, a good chin, and a dynamite punch could bring one to the doorstep of ring immortality. It was often said that he debunked the age-old axiom that great heavyweights are born and not bred. Many thought that his physical shortcomings would end him, but Marciano proved them wrong. In 1952, he knocked out Jersey Joe Wolcott in 13 rounds to win the World Heavyweight Championship. (Author's collection.)

AL GAINER, THE "NEW ENGLAND CYCLONE," 1933. Al Gainer, also known as the "New England Cyclone," was a college man. Born and raised in Florida, Gainer moved to Hartford, Connecticut, after graduating from A and M College. In Connecticut, Gainer worked as a field hand for a tobacco farmer and then for a bricklayer. It was then that he began his boxing career. A long, lithe fighter with fine style, Gainer's best weight hovered around 175 pounds, but he often fought heavyweights. He scored some notable wins, including victories against Tony Galento, Bob Olin, and James Braddock. He fought the tough Jack Fox several times, splitting several decisions and fighting a vicious draw at the Boston Garden. Gainer failed in his only try at the world light heavyweight title, losing in 15 rounds to world champion John Henry Lewis. (Author's collection.)

SAM LANGFORD, 1952. Sam Langford was practically blind when he finished out his career in Mexico in 1925. His star faded quickly as did his funds. There were a few fundraisers for the old pugilist in the late 1920s in Harlem and Boston, but Langford seemed to fade out of the collective memory a few weeks after the events occurred. In the 1940s, a reporter by the name of Al Laney wrote a piece on old-time fighters and tracked Langford down, finding him in a ragged apartment, alone, blind, and very thin. Laney's story brought new attention to the ex-boxers' plight, and several different funds were started to help him with food, clothing, and shelter. He was even given a few free eye operations to assist in restoring his sight, but they were never successful. Langford died in Cambridge in 1953 and is buried there at the city cemetery. (Ben Hawes's collection.)

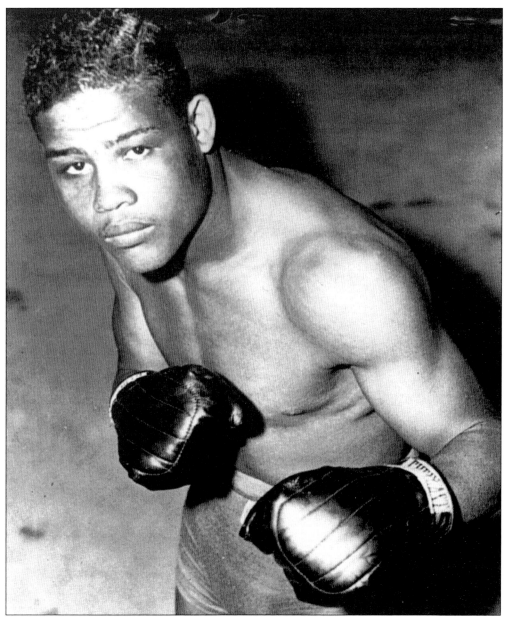

JOE LOUIS, THE "BROWN BOMBER," 1938. The daddy of them all was Joe Louis, also known as the "Brown Bomber." The stone-faced assassin was the longest reigning heavyweight champion of all time. His 12 years as king were longer then some men's careers, and Louis defended his title an unmatched 25 times during that period. His 1939 one-round destruction of Adolph Hitler's Nazi poster boy, Max Schmeling, was perhaps the most important sporting event in the history of the United States and turned Joe Louis from a sporting hero into an American hero. Years before Jackie Robinson broke the color barrier in baseball, Louis made inroads into mainstream white America and practically erased the color line in boxing. Joe Louis's impact on America was immeasurable; there was a death row inmate in Florida who the night before his execution could be heard by the guards throughout the night chanting, "Save me Joe Louis; save me Joe Louis." (Author's collection.)

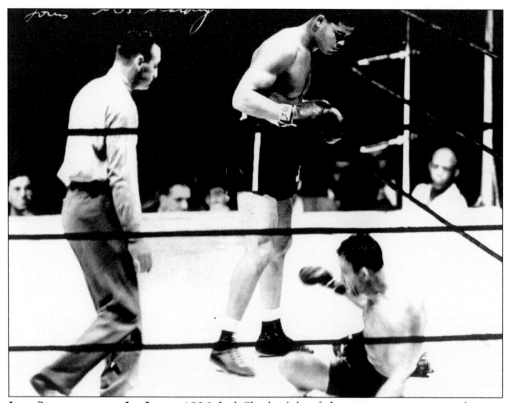

JACK SHARKEY VERSUS JOE LOUIS, 1936. Jack Sharkey's last fight was an unceremonious beating by Joe Louis in New York. "I didn't want that fight," Sharkey remembered years later. "I did that one for Buckley [his manager Johnny Buckley] who was down on his luck. I don't remember much, just the introductions and Joe walking toward me when the bell rang. That was it really. Next thing I know I am being slapped by Buck and looking at Louis in the center of the ring waving to the crowd. He made me forget the rest I guess." (Author's collection.)

JOE LOUIS AND AL MCCOY WEIGH IN, 1940. Joe Louis and Al McCoy are pictured here as they weigh in for their match in 1940. Al McCoy was a native of Maine. In 1940, he was only 28 but a veteran of over 150 fights. Only a light heavyweight, McCoy had never been stopped in his career but was on the short end of three-to-one odds that he would not last the distance against Joe Louis, the heavyweight champion. (The *Boston Globe*.)

A Cartoon of Joe Louis and Al McCoy, 1940. Boston was excited by the prospect of a heavyweight championship bout at the Garden. Despite its long and storied boxing history, Boston had never been the sight of a tilt for the heavyweight title. Al McCoy versus Joe Louis outdid all previous advance sales for a boxing match in Boston. Ticket prices ranged from $2.20 to $5.50, and nearly 15,000 people paid up front to reserve a seat for the contest. They were disappointed. (The *Boston Globe*.)

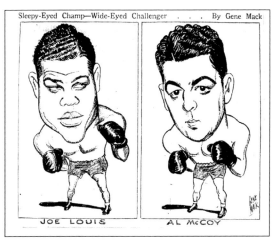

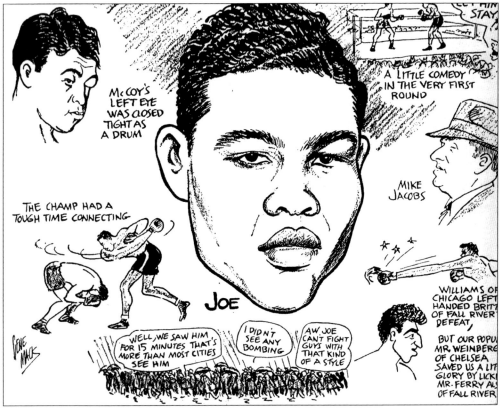

A Post–Fight Cartoon of Joe Louis versus Al McCoy, 1940. The night of December 16, 1940, was a disappointing one for Al McCoy and Boston fans. The highly partisan crowd came to see one of two things happen: McCoy to last the full 15-round distance or Joe Louis at his best. They saw neither. Louis, after a layoff of nearly six months, was not sharp, and poor McCoy tried only to survive. In the second round, Louis caught McCoy with a left hook that damaged his right eye. McCoy simply tried to avoid Louis at any cost. At the end of the sixth round, McCoy's eye was so badly damaged that his corner would not let him come out for the seventh round. Thus, anticlimactically, the first heavyweight championship fight in Boston ended. (The *Boston Globe*.)

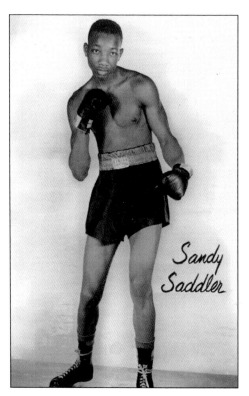

SANDY SADDLER, 1949. Sandy Saddler was born in Boston on June 23, 1926. He moved to Harlem as a youngster and began his professional career at the age of 17. He won the world featherweight crown from Willie Pep in 1948, lost it back to Pep, and then regained it again in 1950. Saddler and Pep fought once more in 1951, and Saddler came out on the winning side again. Their four-bout series went down as one of the more famous and ferocious in history. Saddler also briefly held the world junior lightweight title. His last professional bout was in 1956 when he lost a 10-round decision to Larry Boardman at the Boston Garden. (Author's collection.)

SAL BARTOLO. Sal Bartolo was born in East Boston where he was laid to rest in February of 2002. A well-liked man and a hero to many, Sal won NBA (National Boxing Association) recognition as the World Featherweight Champion when he defeated Phil Terranova on March 10, 1944, at the Boston Garden. Bartolo would defend his title three times in Bean Town before he lost a unification match with the New York champion Willie Pep. (Author's collection.)

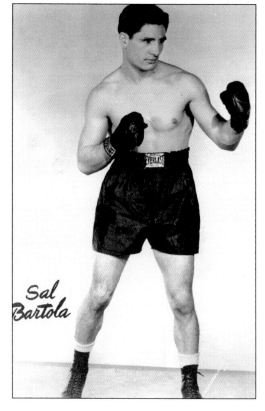

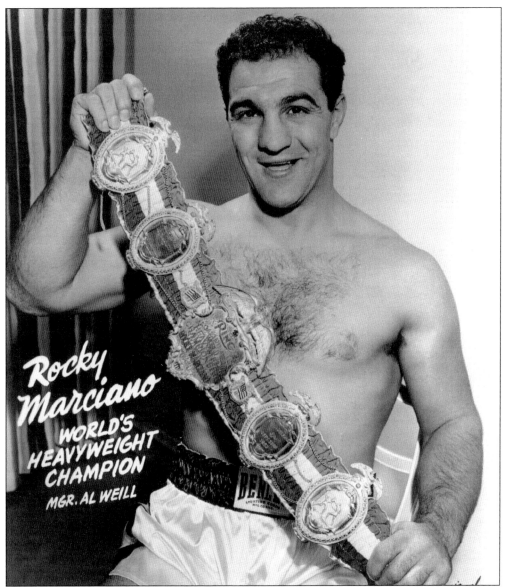

ROCKY MARCIANO WITH HIS CHAMPIONSHIP BELT, 1953. The "Rock," as Marciano was sometimes called, held his championship for close to four years. Oddly enough, although Bostonians like to claim Marciano as their own, he only fought in Boston on two occasions. The majority of his bouts were in Providence, and not one of his title defenses were in New England. Marciano began boxing in the service and, upon his discharge, joined the ranks of the amateur pugilists. He won some acclaim as a New England Golden Gloves Champion, but he was never considered championship material. Even after he turned professional and knocked out 32 of his first 37 opponents, Marciano was not considered a title threat. That changed when he knocked out an ancient Joe Louis in eight rounds in New York. Another four straight knockouts, and Marciano got his title shot against Jersey Joe Wolcott. After 12 grueling rounds, Wolcott was ahead on all scorecards, and Marciano needed to do something big in order to keep his hope alive. That something came in the form of a jolting right hand which caught Wolcott flush on the "button" and made Rocky Marciano the champion. (Author's collection.)

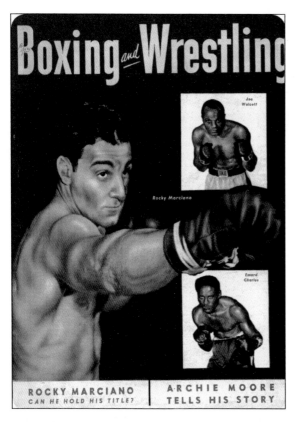

MARCIANO'S *BOXING AND WRESTLING* COVER, 1953. Rocky Marciano made 5 successful defenses of his crown. He knocked out Wolcott in 1 round in their rematch, fought 2 brutal affairs with Ezzard Charles, knocked out Roland La Starza in 11 rounds, Don Cockell in 9 rounds, and Archie Moore (also known as the "Old Mongoose") in 9 rounds. Marciano retired undefeated in 1955. In 1969, he was on a airplane destined for Des Moines, Iowa, where he was scheduled to make a personal appearance, when the airplane crashed, killing all on-board. (Author's collection.)

DOC ALMY HOLDING A PAIR OF JOHN L. SULLIVAN'S SPARRING GLOVES, 1953. The dean of Boston's boxing writers, Doc Almy, wrote a daily boxing column for the *Boston Post* for over 50 years and was considered the expert on the Boston boxing scene. Born only two houses down from John L. Sullivan's home, Almy frequently spoke about his childhood encounters with the famous Sullivan. Out of the thousands of boxers with whom Almy had interacted, he said Langford was the best. "He could do anything in the ring," Almy said, "Anything." He said this about the fighter he liked the least: "They didn't call Jim Jeffries the grizzly bear for nothing. He was an unbearable man!" (Author's collection.)

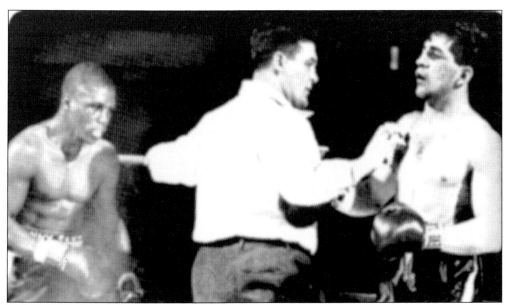

TONY DEMARCO KNOCKS OUT JOHNNY SAXTON, 1955. When Tony DeMarco, born Leonard Liotta in Boston's North End, knocked out Johnny Saxton to win the World Welterweight Championship at the Boston Garden on April 1, 1955, he did not have long to savor his victory. Less than two months later, DeMarco, a true warrior, traveled to Syracuse to take on hometown-tough-guy Carmen Basilio. In a war of attrition, DeMarco came up short and was stopped in the 12th round. (Author's collection.)

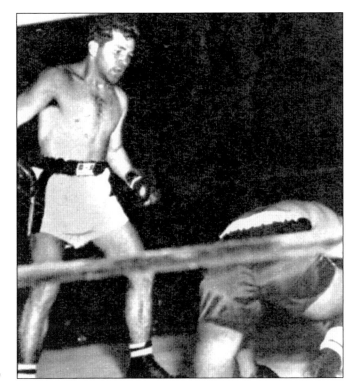

TONY DEMARCO VERSUS CHICO VEJAR, 1955. After taking a few months rest, DeMarco, also known as the "Boston Hurricane," stepped back into the ring with the tough Chico Vejar. Tony was trained to the minute and was bent on getting another crack at Basilio. He stormed from his corner at the first bell and swarmed all over Vejar, knocking him out in the first round. Two months later, he was back in the ring with Basilio for the title. This time the bout took place in Boston. Unfortunately for DeMarco and the 15,000 fans that cheered him on at the Garden that night, he was stopped again in the 12th round. (Author's collection.)

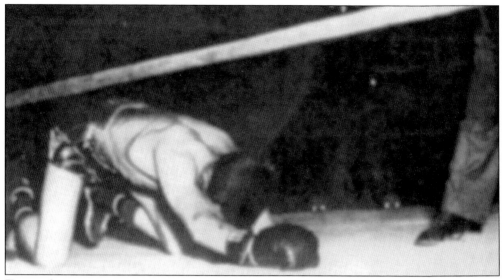

Tommy Collins Hits the Deck. Tommy Collins was a very popular fighter. He was a puncher in the fullest sense of the word. Every punch that he threw was meant to end a fight. There was nothing fancy about him. He was grim, determined, and reckless. That is what the fans loved about Tommy. Unfortunately, Collins often found himself in a seated position on the canvas or face down. But far more times than not, he would pick himself up and get back out to war. (Author's collection.)

Tommy Collins with His Wife. Collins got a crack at Jimmy Carter, world lightweight champion, on April 24, 1953. Carter was a top-flight man and a puncher in his own right. Carter was installed as a favorite, but the Boston faithful knew that Collins always had a chance. The bout was uneventful until the third round when Carter knocked Collins down. Up bounded Collins only to be knocked down again and again. In the next two rounds, he was knocked to the canvas a total of 10 times. Each time he rose again. Finally, in the forth round, the bout was stopped by the referee and brave Collins's championship hopes were dashed. (Author's collection.)